ART...

WHAT IS IT GOOD FOR?

Institute of Ideas
Expanding the Boundaries of Public Debate

Dolan Cummings
David Lee
Ricardo P. Floodsky
Pavel Büchler
Andrew McIlroy
Aidan Campbell
Sacha Craddock

Hodder & Stoughton
A MEMBER OF THE HODDER HEADLINE GROUP

10052218

Orders: please contact Bookpoint Ltd, 130 Milton Park, Abingdon, Oxon OX14 4SB. Telephone: (44) 01235 827720. Fax: (44) 01235 400454. Lines are open from 9.00 - 6.00, Monday to Saturday, with a 24 hour message answering service. You can also order through our website: www.madaboutbooks.com

British Library Cataloguing in Publication Data
A catalogue record for this title is available from
the British Library

ISBN 0 340 84837 5

First Published 2002
Impression number 10 9 8 7 6 5 4 3 2
Year 2007 2006 2005 2004 2003

Typeset by Transet Limited, Coventry, England.
Printed in Great Britain for Hodder & Stoughton Educational, a division of Hodder Headline Plc, 338 Euston Road, London NW1 3BH by Cox & Wyman, Reading, Berks.

700

Luton Sixth Form College
Bradgers Hill Road, Luton Beds. LU2 7EW

Return on or before the last date stamped below

P9794

DEBATING MATTERS

DEBATING MATTERS

CONTENTS

PREFACE

Since the summer of 2000, the Institute of Ideas (IoI) has organized a wide range of live debates, conferences and salons on issues of the day. The success of these events indicates a thirst for intelligent debate that goes beyond the headline or the sound-bite. The IoI was delighted to be approached by Hodder & Stoughton, with a proposal for a set of books modelled on this kind of debate. The *Debating Matters* series is the result and reflects the Institute's commitment to opening up discussions on issues which are often talked about in the public realm, but rarely interrogated outside academia, government committee or specialist milieu. Each book comprises a set of essays, which address one of four themes: law, science, society and the arts and media.

Our aim is to avoid approaching questions in too black and white a way. Instead, in each book, essayists will give voice to the various sides of the debate on contentious contemporary issues, in a readable style. Sometimes approaches will overlap, but from different perspectives and some contributors may not take a 'for or against' stance, but simply present the evidence dispassionately.

Debating Matters dwells on issues that have emerged over the last few years, but are more than short-lived fads. For example, anxieties about the problem of 'designer babies', discussed in another book in this series, have risen over the past decade. But further scientific developments in reproductive technology, accompanied by a widespread cultural distrust of the implications of these developments,

means the debate about 'designer babies' is set to continue. Similarly, preoccupations with the weather may hit the news at times of flooding or extreme weather conditions, but the underlying concern about global warming and the idea that man's intervention into nature is causing the world harm, addressed in another book in the *Debating Matters* series, is an enduring theme in contemporary culture.

At the heart of the series is the recognition that in today's culture, debate is too frequently sidelined. So-called political correctness has ruled out too many issues as inappropriate for debate. The oft noted 'dumbing down' of culture and education has taken its toll on intelligent and challenging public discussion. In the House of Commons, and in politics more generally, exchanges of views are downgraded in favour of consensus and arguments over matters of principle are a rarity. In our universities, current relativist orthodoxy celebrates all views as equal as though there are no arguments to win. Whatever the cause, many in academia bemoan the loss of the vibrant contestation and robust refutation of ideas in seminars, lecture halls and research papers. Trends in the media have led to more 'reality TV', than TV debates about real issues and newspapers favour the personal column rather than the extended polemical essay. All these trends and more have had a chilling effect on debate.

But for society in general, and for individuals within it, the need for a robust intellectual approach to major issues of our day is essential. The *Debating Matters* series is one contribution to encouraging contest about ideas, so vital if we are to understand the world and play a part in shaping its future. You may not agree with all the essays in the *Debating Matters* series and you may not find all your questions answered or all your intellectual curiosity sated, but we hope you will find the essays stimulating, thought provoking and a spur to carrying on the debate long after you have closed the book.

Claire Fox, Director, Institute of Ideas

NOTES ON THE CONTRIBUTORS

Pavel Büchler is an artist and teacher. He was head of the School of Fine Art at Glasgow School of Art from 1992–5 and in 1997 he was appointed Research Professor in Art and Design at Manchester Metropolitan University. His recent projects include an LP entitled *Live* (1999), a book of essays on photography and film, *Ghost Stories*, (Proboscis, 1999) and the Manchester Pavilion at Venice Biennale 2001.

Aidan Campbell is the author of *Western Primitivism, African Ethnicity* (Cassell, 1997). He is currently working on a book about contemporary art, expanding on the issues dealt with in his essay in this collection.

Sacha Craddock is an independent art critic. She teaches at many art colleges, writes articles, catalogue essays and gives public lectures. The chair of New Contemporaries and jury member for the 2001 Jerwood Painting prize, she is in the process of setting up *Monitor*, a publication that will establish a forum for critical writing and discussion.

Dolan Cummings works at the Institute of Ideas and is commissioning editor for the arts and media section of the *Debating Matters* series. He is the author of *In Search of Sesame Street: Policing Civility for the 21st Century* (Sheffield Hallam University Press, 1999) and he writes a weekly television column for www.spiked-online.com.

Ricardo P. Floodsky is a leading art critic. He edits www.artrumour.com – a web-based insiders' guide to the art world filled with salacious gossip, hard-hitting news and plenty of factual errors.

David Lee is editor of *The Jackdaw*, an alternative newsletter for the visual arts.

Andrew McIlroy works as an international advisor on cultural policy and has worked with the Council of Europe and the European Commission, as well as with a variety of organizations in the UK advising on fundraising, the management of change and developing public policy.

INTRODUCTION
Dolan Cummings

I don't know much about art, but I know what I hate
Montgomary Burns, *The Simpsons*

Art is in. Over the last decade, visual art has become perhaps more
popular and fashionable than ever before. Damien Hirst, Tracey
Emin and the other so-called Young British Artists (YBAs) are
treated like popstars. Exhibitions like Charles Saatchi's infamous
Sensation capture the public imagination and make the headlines.
Tate Modern has been a success beyond all expectations, with
crowds flooding in to see contemporary work.

For all its success, however, contemporary art is also a source of
consternation. The very novelty that appeals to so many people is to
others a betrayal of art itself. The most prominent new work tends
to be 'conceptual'. This is a label developed through the 1960s and
1970s to describe art in which the concept embodied in a work is
more important than the object itself. Conceptual artists were less
interested in making beautiful paintings and sculptures than in
using the processes of art to explore ideas and challenge
orthodoxies, whether artistic or political.

The art of the YBAs is arguably less intellectually and politically
charged than that of their forebears, but it uses many of the same
techniques and ideas. Conceptualism built on earlier art including

that of Marcel Duchamp, who famously exhibited a urinal (*Fountain*, 1917). Similarly, contemporary works are not necessarily made directly by the artist and this is something that particularly upsets traditionalists. The most controversial works tend to be 'installations', such as Tracey Emin's notorious *My Bed* (1998), with bits and pieces, sometimes ready-made and sometimes specially manufactured, arranged for effect in particular spaces.

When an exhibition of Vermeer paintings opened at the National Gallery in the summer of 2001, the *Guardian* reproduced one of his paintings along with a photograph of an exploding installation by the contemporary British artist, Cornelia Parker. The contrast between the Dutch Master's breathtaking technical skill and the apparent artlessness of the installation contained an implicit challenge: Why can't the YBAs paint like that, like *proper* artists?

It is not just the copy-hungry press that questions the validity of conceptual art. In 2001 the playwright Tom Stoppard gave a speech at the Royal Academy of Arts lamenting the demise of craft, suggesting that contemporary art has lost its way. In 1999 a group of young artists including Billy Childish launched a manifesto declaring a return to real art. The group took the name Stuckist, self-consciously embracing Tracey Emin's charge that they are 'stuck, stuck, stuck in the past.'

Many outside the art world are reluctant to dismiss contemporary art out of hand, but struggle to find a way in. It sometimes seems that art has developed a 'take it or leave it' quality: the public feels obliged to choose between an uncritical acceptance of contemporary work and a bewildered disengagement. We are either schmucks or philistines.

The situation is further complicated by the Government's interest in the arts. Since its election in 1997, New Labour has put the 'creative industries' at the heart of its vision for the future of Britain. In the late 1990s, the Young British Artists were embraced, along with Britpop and British fashion, as part of Cool Britannia. For its second term in office New Labour has identified art as one of the key ways to tackle social exclusion. According to the Department for Culture, Media and Sport, 'The arts can contribute to neighbourhood renewal and make a real difference to health, crime, employment and education in deprived communities' (DCMS Green Paper, *Culture and Creativity: The Next Ten Years*, 30 March 2001). It has put the search for new audiences and community involvement at the centre of its arts policy.

All this has raised fears that the Government's meddling will undermine the essence of art, by subordinating aesthetic judgement to political considerations. A group of artists and others, including the philosopher Baroness Mary Warnock, collaborated on a book called *Art For All?* to challenge New Labour's agenda. In it they contend that charges of elitism and calls to be more socially responsible are undermining artists' creativity. The argument against overbearing arts policy takes other forms too, whether it is a clarion call for 'art for art's sake' or simply a plea for the space to practise art without worrying about what kind of audience the work will attract.

It may perhaps seem perverse that such critics and others complain when the Government is offering the arts such enthusiastic support, but it could be argued that art fares better in a hostile political environment, where there is a spur to kick against the establishment. Indeed, it is striking that for all its radicalism and controversy, contemporary art has become utterly mainstream. It is embraced not only by government and the gallery-going public but also by the

commercial world. This indicates that the current controversy is not simply the familiar clash between sleepy tradition and the avant garde. The break with the past is more complete. It is art conservatives who are on the margins now, while the neo-conceptual *enfants terribles* dominate the coveted Turner Prize. While the question 'What is art for?' has been asked throughout the decades, the essays in this collection have therefore been written in a context that has much to distinguish it from the past.

David Lee, author of the first essay in this book, is very much a dissident in the world of art and has made himself unpopular with many for his acerbic attacks in his newsletter, *The Jackdaw*, on what he calls 'State art'. In his essay, Lee describes his own passion for the 'magical grace' of classical sculpture. For Lee, qualities such as beauty and craft have been undermined by the professionalization of art, with legions of bureaucrats and curators charged with generating audiences and interpreting art for them in ever more outlandish terms. Lee argues that art is never likely to appeal to a mass audience and that we should not expect it to change the world.

Ricardo P. Floodsky might be seen as the polar opposite of David Lee. Floodsky edits a website called artrumour.com, a guide to the world of contemporary art, and has little interest in classical or indeed any 'old' art, or in the craft that went into it. And for Floodsky, our appreciation of art is inevitably affected by what we bring to it: it is political, historical, social and so on. In common with David Lee, however, Floodsky is sceptical about the interpretation of art. His essay is really about the visceral effect of art – an effect well worth thinking about when considering the question 'What is art for?' – so we will have to ask readers in advance to ignore his injunction not to read this book through.

The other side of the question is the motivation and practice of the artist, an issue addressed by Pavel Büchler, artist and Research Professor in Art and Design at Manchester Metropolitan University. His views are anathema to conservatives, and would raise eyebrows even in more sympathetic company. Büchler argues that the identity of the artist, and his or her relationship to society, is more important than any actual work of art. In art, unlike science, subjectivity is everything and for Büchler it is the subjectivity of artists – what artists do rather than what they make – that counts. He argues that art education should be concerned less with the production of art and more with an understanding of what it means to be an artist. This argument appears contentious, but it is implicit in much current discussion about contemporary art.

Andrew McIlroy takes a similar approach, but focuses on the audience rather than the artist. McIlroy is a cultural policy advisor to the European Union and a consultant with Arts and Business, an organization that fosters links between the two worlds. For McIlroy, the value of art is functional at least as much as it is critical. Experts can argue about whether or not a particular work is great art, but ultimately what matters is the effect that work has on its audience. McIlroy points out that art has always served society in various ways, and suggests that we should make the most of what art can bring to the workplace, to hospitals and so on, rather than worrying about aesthetic purity.

Against all this, Aidan Campbell argues that art's capacity to change the world is often overestimated, while its aesthetic value is downplayed. For Campbell, the current popularity of art reflects society's preference for images over objects. He argues that art is at its best when it is peripheral, rather than being forced to account for itself in the spotlight. If art is given the freedom to be useless and

even antisocial, then paradoxically it is more likely to offer inspiration, proving its real value.

Sacha Craddock argues that the attempt to define art can impair our appreciation. For Craddock, the gap between art and its interpretation is very precious, and the current tendency to demand meaning immediately from a work goes against the essence of art. Instead, Craddock considers both affect (the motivation of the artist) and effect (on the viewer). In addressing the difficulties of definition in this way, Craddock examines what it is that makes visual art special.

Each of the contributors to this book has a different view on the meaning and function of art. At a time when discussions about art seem to address everything but art itself it is refreshing to read a variety of perspectives on the controversies in contemporary art and what they tell us about art itself. Reading the book is no substitute for *looking* at art – nothing is – but we hope that the essays will inspire readers to *think* about art too.

Essay One

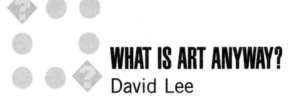

WHAT IS ART ANYWAY?
David Lee

Entry to the British Museum is free for all. If anyone ever takes away my right to see for free whenever I want the objects I own and which, if you are a British citizen you own too, there will be civil disobedience. For a number of years while I was employed in demoralizing and repetitive office work in Central London, the British Museum was among the national museums I visited often during the lunch hour. There would be weeks when I would pop in every day, sometimes briefly but rarely for longer than an hour. My preferred areas were Classical Greece and Rome, an area of history in which I have had, to my deep regret, no formal education. Otherwise it would be the Print Room which, it being quiet, cool and customarily deserted, I have always thought of almost a haven of security from the barbarisms and miseries of everyday life.

What do I look at in the Greek galleries? I know passably well a very few of the greatest works of sculpture ever created. My interest is that of the modestly informed amateur. My wife was born in Turkey and is a fluent Turkish speaker, so we have been fortunate enough to have visited the often very remote places where some of these sculptures were excavated. Each of the works I have drawn (at best badly because I have enjoyed no formal education in that discipline either) many times.

Like museum going, drawing for me is a form of therapy and conclusive escape. At no other time am I so possessed by

concentration as when studying and drawing either the fragmented sea nymphs from a tomb in Xanthos, in the ancient province in Lycia, now south-western Turkey, or certain of the pediment figures from the Parthenon Frieze, or some favourite naked warriors of the Bassae Frieze. All these figures are carved in marble and I could spend pages describing them, which would be pointless. The effect they have on my eyes is not translatable into words. If you have discovered the high of acute concentration and the rewards of looking for yourself you will know what I mean.

Also, I am vulgar and unfashionable enough to be in awed thrall to the unteachable and inimitable skills of the people who made these objects, for these are among the most beautiful sculptures I have ever seen. Astonishingly, human beings made them, and the belief of these men in the purpose they were serving becomes an almost tangible commodity through their refined labours. The Xanthos nymphs have a magical grace which defeats the stone's weight. It is a conjuring trick which thrills me every time as much as the first occasion I saw a television magician pull a loft's worth of doves from a top hat. Any attempt at interrogating ancient objects at this great conceptual distance from the moment they were brought to life poses page after page of unanswerable questions for the unscholarly such as myself. I have never left the British Museum in a lower mood than when I entered. Yes, for those few minutes it feels good to be alive.

Recently I spent the afternoon, before delivering an evening lecture in Birmingham, at the Barber Institute and at the City Art Gallery. I doubt if at both museums I encountered a dozen others in total all afternoon. Of course, the experience was perfect for me; no kids, no yakkers, no muscling in. Apart from the periodic distraction of an attendant gabbling into an invasive walkie-talkie I could have pretended that

both galleries were my private collections. Is this apparent neglect to do with these places having rotten collections? Absolutely not. Were there prohibitive entrance charges? No, both were free. So where were the other 2,999,988 people who are alleged to live within the sprawling Birmingham conurbation?

By the end of the afternoon it had hit me in a flash of paranoia what a truly endangered species those who enjoy looking at art are. 'Why am I so sad that I am alone in these rooms?' I thought. If Birmingham and recent similar experiences in Coventry, Leeds, Nottingham, Bolton, Southampton, Newcastle and Liverpool are anything to go by, museums and visual art are in the throes of a slow death. In the future, Old Masters will be replaced by photographs celebrating the cultural diversity of the museum's constituency. Even fewer will turn out for that kind of patronising rubbish which will have been dreamed up by unlettered councillors who believe all past art is tainted with elitism and has got to go.

Museums are losing out, and will eventually lose out completely, to other more facile, passive, home-based forms of escapism. I bet that over the next ten years as museum attendances decline obesity increases in proportion. The only logical conclusion to be derived from my recent experience is that if you visit any regional art gallery, whether it be weekend or weekday, the short odds will be on your having the place to yourself.

Museums and museum directors have been blamed for the brazen failures of state education, one of whose chief shortcomings has been the total neglect of visual literacy. Many directors have bravely resisted considerable duress and threats by refusing to turn some of the world's artistic treasure houses into theme parks. All they can reasonably do is to throw open the doors and say, 'Come and see these amazing things. It will cost you nothing but your time and commitment.'

In the end there is no substitute for willing effort on the part of the viewer. Genuine curiosity has to precede the enjoyment of art. Through no fault of their own, many people are not in the least curious about anything that does not feed the dangerous mass addiction the majority of our country exhibits for shopping and squandering money on trivial possessions. Additionally, they have lost (if they ever owned) the powers of concentration required to break into the realms of quiet contemplation where art may reveal itself and flourish. Art is not like raspberry cordial: it cannot be diluted to taste.

Anyway, art, and the experience of it, is not vital or essential sustenance for the overwhelming majority who have perhaps learned to enjoy other, easier forms of pleasure requiring slightly less mental inquiry. I remain convinced that for the small majority of the population which all recent surveys have suggested never go to art exhibitions and probably never will, that if you stood the Rondanini Pietà in their front garden, or perhaps placed Alexander's head from Pergamon on their window sill and dispensed free glasses of plonk and packeted confectionery they might, just might, prise themselves away from the television in order to peer through the curtains at the rumpus, but they would not venture outside, not if *The Generation Game* were on, anyway.

I do not have the faintest idea what art is but whatever it looks like, sounds like, reads like, it is the polar opposite of *The Generation Game*. *The Generation Game* is what is vouchsafed to an easily entertained and amused comatose mob that has been shut off by rotten education from anything that might involve thinking or imagining.

With one child staying the night with a friend, an event my daughter insists on calling a 'sleepover', and the other apparently terminally hypnotized by the internet, my wife and I decided to enjoy our

wholesome soup in front of Saturday evening television. What a relief, a few minutes release from torture by children. We began watching this deafeningly loud, blindingly bright programme. Before being asked to do things which an expert has first demonstrated and made look easy, such as filling sausage skins with what looked like cat sick, volunteers were asked stupid questions to which, smirking conspiratorially and with a truly nauseating display of bogus familiarity towards the show's host, they splutter obviously scripted answers seasoned with obligatory single entendres. An audience of fat epsilons laughs like a collective drain, often and long. After five minutes we switched over to something else; soon after that to something else again, until we were forced to switch off altogether and actually talk to one another.

Anyone who can sit and watch with enjoyment such demeaning, insulting trash has to be a closed book to art (now there's a definition for you). To be moved by art and to enjoy *The Generation Game* are impossibilities in the same person. They require nervous systems which have been nurtured in different, mutually exclusive directions. It barely needs stating that *The Generation Game* is one of the most popular programmes on television. Millions, I am told, have been watching it loyally every week for decades. They watch it willingly for pleasure and quite possibly look forward with anticipation to it coming on. Waking on a Saturday morning, perhaps they open their eyes and then suddenly it dawns. 'Yes!' they shout, flexing their biceps like a goalscorer. 'It's *The Generation Game* tonight!' They rise, collect their tabloid newspaper from the mat, throw a teabag into a mug and return to bed with six steaming pop tarts. Who needs art? This is living, this is real life.

Like art, *The Generation Game* helps pass the time painlessly, the difference being that the former might be productive and edifying in

some way. *The Generation Game* cannot be edifying even to those who make a point of watching it, but BUT we should always remember that millions have lived long, full, productive and selflessly generous lives in total ignorance of art while carrying through life an encyclopedic knowledge of *The Generation Game*.

Nonetheless, everybody says art is a good thing and it is, you know it is, we all know it is... but not today, thanks. Art is not that tempting when there is an easier, more instantly gratifying, and totally effortless alternative. In an age where shopping, spending, shopping, fast food, shopping and *The Generation Game* are chief and probably terminal addictions, art is an aspiration, something for next week but not just now because the bathroom needs painting and then the German Grand Prix's on. So we are all agreed on that then: whatever it is, art is a jolly good thing and good luck to it.

So, for most of the population, art, like poetry or prose, drama or music, does not hit the spot. It just doesn't and it is the failure of successive governments to admit that it probably never will that has led our cultural leaders down the road of ridiculous popularizing schemes devised to boost museum attendances. Providing museum attendances keep increasing, New Labour can pretend that it is nourishing the cultural aspirations of its core constituency; that is, by and large, those who would not, under normal circumstances, be seen dead or alive in an art gallery.

They have had no success in this drive, although the Ministry of Culture has recently often given the impression that they have. When the statistical blip of Tate Modern, with its 5.5 million visitors against a projected 2.5 million, is discarded, museum and gallery attendance has dropped by seven per cent over the last five years for

which reliable figures exist and the disaffection between the greater populace and museums is especially acute in the provinces where statistics are relatively uncontaminated by tourism.

So what is art, anyway? Probably it is simpler to state what art is not. Art is nothing to do with what self-justifying art professionals conspire to tell you it is about. It has nothing to do with 'challenging notions of this', 'expanding the horizons of the other', 'toying with concepts of', 'inviting references to', 'subverting accepted conventions of', 'transcending preconceptions about', 'significantly extending the language of' or any of the other preposterous nonsense that gets written about it. In the case of contemporary art, *Curators of Interpretation*, a recent addition to the art careers ladder, make up meanings in order to convince you that you're looking at something important when what you see appears entirely negligible.

It is not about contexts, site specifics or invisibles that an apologist is claiming to be able to see. It is not about 'the space', 'the hang' or any of the other obsessional obfuscations caused by the professionalizing of art and its presentation to, and interpretation for, the public. It is especially nothing to do with any of the written gibberish and periphrastics that sad, half-literate curators invent in order to justify exhibiting the trash that for some inexplicable reason happens to have captured their interest. Appreciation of art is never an act of blind faith, of believing what one is told to believe because one can't see it for oneself. The qualities of art should not have to be taken on trust as if it was some sort of religious belief.

If art's coverage and presentation has a problem it has been caused by the overprofessionalizing and institutionalizing especially of contemporary and recent art. Tate Modern is a living monument to this grotesque mistake. To an outsider it seems that teams of

curators compete with one another to curate the life out of everything they see and touch in order only to prosecute their own wildly fanciful interpretations. They are terrified to let the work speak for itself because too often they are incapable of identifying work that is not dumb or indeed stillborn. The same senseless curatorial meddling vandalized Tate Britain two years ago when some prize buffoon shuffled the historical British collection and then threw it on the wall claiming all manner of ludicrous parallels between historically distant works, so visitors were comprehensively disoriented. Additionally, it was impossible to find anything. Visiting that gallery became dispiriting and bewildering even for regulars. Attendances plummeted.

Curators, it seems, are now obsessed with every detail that is irrelevant; they seem incapable of the critical insight which sparks understanding. They seem to have forgotten that most go to galleries for the purpose of pleasure, pure and simple.

That grand paradigm and personification of this humourless professionalizing of art administration, Sir Nicholas Serota, recently supplied an example of how the wrong goals can become an unhealthy obsession. His Dimbleby Lecture last year, riddled as it was with inconsistencies and special pleadings, not to mention those personal obsessions which have driven state policies on contemporary art to an extreme of unhealthy censorship, ought to have alerted anyone who heard it to the flairless rot one was about to read. This article concerned one of Serota's tedious obsessions: 'spaces' – the hang, the light, gallery design – indeed anything apparently but the work. He began: 'We intuitively understand that the physical character of the space in which we encounter a painting or sculpture can influence our appreciation of it'.

Wrong. We do not. Another blathering museum professional, pompous in the extreme, might concur with Serota's supposition, but the vast majority of museum goers are unconcerned with such affairs and wouldn't mind at all if they were apprised of these calculations even existing. In the earlier days of the art bureaucrat, the considerations that now nag Serota and his carefully selected lickspittles, were taken for granted because the dominant concern used to be scholarship to which everything else was subservient.

Now, with the professionalizing of every aspect of museums, there are so many bureaucrats with apparently so little to do, that all they can manage is to sit on committees hand wringing about the 'hang' and the 'look' and 'feel' of 'spaces'. Thinking about it, modern curators have to do something to justify their index-linked pensions, but scholarship is effectively closed to them. What scholarship can possibly be involved when a work, for which there are no known criteria of appreciation or criticism, was created yesterday and the artist is on hand to convey exhaustively everything we need to know about it?

No. None of this matters a fig. Gallery goers are not interested and do not care. The results of the art professionals' obsessions are addressed only to other art professionals, but it is the self-delusion of these careerists that they believe visitors care about such things. They do not. Equally, the self-delusion of exhibition curators is that visitors will notice that an early X is hung beside a late Y and that the visitor will somehow magically follow an unintelligible curatorial thread weaving through the 'spaces' of an exhibition. Sorry lads, but we do not notice and we do not care, unless of course you exceed even your own levels of incompetence and mess things up to the degree that Tate Britain did with its rehang.

Why don't we care? Because art is not about any of these fads. It is purer than this. It is about a work of art and a pair of eyes and the desire of the owner of that pair of eyes to escape, to experience a small satisfaction, to have an imagination aroused, to have ambitions confirmed and perhaps even to learn something about a different period. Principally, visual art is about that pleasure to be derived from looking which cannot be reduced convincingly to words. The rest is irrelevant, indeed it is an invention to justify the employment of legions of pseudo-intellectuals.

I am at Venice Biennale, summer 2001. Hot, broke and bored to tears by room after room of dull, flickering, often malfunctioning and interminable videos with neither technical nor visual nor narrative skills. The arrogance and conceit on display from posturing artists and officials takes one's breath away. What on earth would a great artist of the past make of this sick circus? On Giudecca, five minutes' walk along the quay from Palladio's Il Redentore, which was *in restauro* and therefore inelegantly wrapped up in plastic sheeting and scaffold, was a piece by a nominee for the Turner Prize for 2001, Mike Nelson. All such trainee high priests are usually dead ringers for a good laugh and it was convenient for me to squeeze this in on the way to catch the bus from Piazzale Roma back to the campsite.

Nelson had taken nine weeks building this piece into an old brewery. It was a network of rooms, each of which had three doors, which slammed; you entered by one and chose from two others to leave by. Each room was a meticulous stage set, so intelligently, pointedly observed. All derived from the sleazy end of life; low bureaucracy in undeveloped countries, seedy bars, lobbies, rooms with religious fixtures and others strong with the threat of imprisonment, clandestine militarism and torture. Doors bang in the distance, followed by footsteps in passages – those of your fellow art lovers.

Here was an imagined sense of what goes on behind the closed doors of an unfindable Middle Eastern back street, a compendium of ills from the world's troubled spots. If this had been real it was not the place you would have wanted to be. The whispers of others could be heard in other rooms. Doors banged again. Somewhere, something was afoot. Steps were retrod, familiar rooms were re-entered bu the door you had not previously selected. Then, the persistent and resilient eventually located a door, opening on to a narrow staircase leading to a dark attic balcony overlooking the network of ceilinged rooms where the progress of others could be followed by doors shutting. Perched here it was easy to imagine oneself the dramatist, even the god, pulling strings. Whatever real or imaginary fears this construction concerned it was powerfully effective beyond its means. I missed the bus.

Essay Two

ART: WHAT'S IT ALL ABOUT THEN?
Ricardo P. Floodsky

Hello. I am Ricardo P. Floodsky. No, that is not my real name. And no, it does not matter that I am using a ridiculous pseudonym. I write about contemporary art in a variety of guises. I also edit a website called artrumour.com – a gossipy trawl through the murky world of contemporary art. I like art a great deal. In fact, I would say it was one of the most important things in my life at the moment. Now, I am not the type of person to bandy claims like that around lightly, so I would like to think that you are at least momentarily touched by my moment of sharing. Presumably, you are quite interested in art. Or perhaps you think it is all a con. Either way: here is the first piece of advice. Stop reading.

If you have not bought this book and are just leafing through it in a bookstore, do not buy it. Put it down and leave the store. If you have bought the book: hard luck. Whatever. Put it down. Go and see some art. If you do not like the art you see, go and see some different art until you find some stuff you like. Find something written about the art you like and read about it. If you think the stuff you are reading is boring, chuck it away. Find some more interesting stuff if there is any around. If there isn't, I would like to apologize on behalf of the community of writers and scholars whose job it is to write about art – a community I am proud to be a part of. Unfortunately, quite a few of my colleagues are fairly useless at this. I am sorry. Still here? Well, that is your choice. Don't tell me I didn't warn you. Here is a story about art.

In 1993 I went to the Courtauld Institute of Art to do an MA in Art History. The Courtauld is the most well-known institution that teaches art history – it has a gallery attached to it, lots of important works of art and is generally recognized as some sort of bastion of the art history world. I did not really know why I was doing art history. It meant that I did not have to get a job for a year and at the back of my mind I figured that I quite liked art – not much more than many other things in my life at that time, but whatever. I lived in a slightly dodgy part of Hackney at the time, out towards the Hackney Marshes. I commuted into the Courtauld on either the North London Line and the tube or the interminably depressing Number 26 bus. During this journey, I generally got angry.

Okay, I was young. I was, I suppose, an angry young man. But, despite this sounding all a bit precious, I definitely got angry. And generally I got angry in a kind of adolescent manner and my anger was generally directed at the Courtauld. The Courtauld was lovely and posh, filled with students who looked like they were on a finishing course in middle Europe. Let's not beat around the bush here. Most of the students were rich, with fine bone structure and thought art was the kind of thing that was suitable to do. They kind of looked, and sounded, strangely interchangeable. Even worse, most of them lived in West London – at that time, a terrible crime in my eyes. I am sure they were not as bad as I make them out to be, but that is how it struck me then. The Courtauld itself was all pillars and graceful statues on the staircases. We learnt about the 'Masters' (and the very occasional mistresses) of art – in my case, modern art. At first I could not put my finger on why I was angry. I guess it was something to do with standing on a dingy, dirty platform in Homerton and wondering why it was so incongruous with the rarefied atmosphere of the institution I was travelling to.

When I wasn't trundling into the Courtauld to learn about Cubism and such other delights, I trudged around Hackney. In particular, I trudged around Victoria Park and to Mile End, where a friend of mine lived. Walking to her house, I would walk down Grove Road. At some point (I cannot quite remember when), a house appeared, or rather a whole load of houses disappeared and one remained – well, sort of, remained. Okay – let me explain. A terrace of Victorian houses was due to be demolished. An artist named Rachel Whiteread had successfully obtained permission to make some art using one of the houses. So when the others were knocked down, she made some art. She filled the house which had been allotted to her with concrete, rather like the way you made those plaster of Paris castings when you were a kid. Then she got rid of the house, leaving a concrete cast of its interior standing. It stood by itself in a smallish area of grass – all the rest of the houses had been knocked down. She called it 'House'.

To tell you the truth, it took a while for me to notice it. There was quite a bit of press about it and people were chattering about it, but I guess I was too busy being angry. I first noticed it at night, lit by the streetlights of Grove Road. It looked good, but that was about it. I stopped and stared and then I went home. All right, I thought. That's 'House'. I continued going into the Courtauld, doing my art history and feeling angry. And I continued to walk past 'House'. And what was odd was that each day there would be more and more people there. Graffiti started appearing. Some of it – not very much – was along the 'what's this all about' line. Far more interesting though, was the rest of it. Some of it was about the proposed M11 extension, which was controversially just going ahead in Leyton and Wanstead, knocking down swathes of housing as it went. Some of it was about housing conditions. Some of it protested against the BNP who were enjoying some success on the Isle of Dogs to the south. And the people around 'House' were milling around, talking about

the things that were graffitied on, and talking about the controversy that was growing about the demolition of 'House'. When Whiteread got permission for 'House', she was told it would be for a limited period of time and then it would be demolished. As 'House' grew in popularity, more and more people argued that it should not be demolished. The local council were against this and wanted it to be demolished as originally agreed.

Around this time, Whiteread came into the Courtauld to do a talk. She seemed a quiet, intelligent artist who was thoroughly fazed by the media controversy that was growing around 'House'. She also seemed, understandably, defensive. When asked about the graffiti and the people who were bringing their own causes – like the M11 protestors – to 'House', she stated that she was only interested in her original idea. She seemed a bit freaked that so many different people were bringing so many different readings to 'House'. Fair enough I thought, but I could not help thinking that those readings other people were bringing to it were the things that were attracting me increasingly to 'House'. One day when I strolled past, I noticed that the latest addition was an estate agents 'For Sale' board that had been stolen and stuck in front of 'House'. It was brilliant, funny and sad. It lasted a couple of days before it was taken away.

I found myself spending more time at 'House' and one day it struck me that 'House' meant more to me than anything I had studied during my year at the Courtauld. It kind of spoke to me. In a weird way it articulated all that diffuse anger I had been feeling; about the disparity between the degraded streets of Homerton and the overly delightful environs of the Courtauld; about the disparity between most of those who were into art, and those for whom art was something that had nothing to do with everyday living. I am not saying I had an epiphany. I did not stand there one day, and think: 'Yes. "House" has

answered all my questions.' It was more of a creeping realization. Aside from me, it was becoming clear that 'House' struck a chord with a number of people and a number of different interest groups, not all of whom could be classified as your typical art lover. This was not Whiteread's intention. It just did. It worked on a number of different levels; it was about history, memory, place, domesticity, the M11, the BNP, the East End. It was sometimes about more than one of these things at once; it was sometimes about none of these things. I stopped feeling angry about art. In fact, 'House' kind of saved art for me. It proved the most important thing that art history books had failed to teach me; that art could do things for me and that it could do things for other people as well, and we could all get something out of trying to think about why and how it did that.

'House' now exists as a memory and in photographs. The council got its way and 'House' was demolished. The large square of grass was left unoccupied. There are now rumours going round that the council want to build a sculpture park there. I am sure they will plan it so that it does all those things that people in government think art should do; you know, all that gush about making a real difference to health, crime, education and tackling social exclusion. If the rumours are true and the sculpture park does go ahead, it will fail to do any of these things. It will look like all the other sculpture parks you see dotted about; patronizing and dull. People will ignore it, urinate on it and generally use it to anchor arguments about why art is rubbish. 'House' worked. It worked at a particular time, in a particular place. You generally cannot legislate for that. It did all those things that government bods think art should do, but that is not why it worked. Like I have said: it just did.

So what is the point of the story? Here is the point: books like this are generally useless. You want answers about art. You want me to tell you

what art is. You want me to consider whether all that contemporary stuff is really art. You want me to consider if the Government's rather instrumental views on art are simplistic. (Well, actually, I can answer that one – yes they are. But I am certainly not advocating art for art's sake either – that is a stupid argument. You bring stuff to art. What you think, what mood you are in, what you believe, what other art you have seen. The idea that art is a self-contained thing goes down the tube as soon as you bring all that stuff. And you can't *not*. Okay, enough over-clever answers, back to criticizing this book.) I cannot tell you what art is and I believe that people who think they can are lying. All I can say is this: art is a bit like a language. You do not have to know the lingo inside out to get something out of it, but you are not going to get anything out of it if you do not know a smidgen. Unfortunately, most writing about art is pompous, overblown and badly written. That is a shame, because it puts most people off wanting to learn anything about art. And do not think you can bypass it and just stand in front of something and wait for that aesthetic thing to happen. It doesn't. Believe me. I have wasted far too much time standing in front of paintings waiting for it to happen to me. Conversely, that does not mean that art is all about reading loads of books and bringing your clever theories to the art object. See what I mean about not being able to answer your questions?

It is more like this: learning about art and seeing art puts you in a position where a piece of art can 'hail' you. What do I mean by 'hail'? (Those of you who are overly clever might realize I have nicked the term from that hoary old Marxist, Louis Althusser.) Okay, it is not as if the work of art cries out to you, it is more that it activates all those nuggets of information and those memories of other bits of art within you and then takes you slightly beyond them. This last bit is the bit that most writing about art fails to tell you. Writing about art does not 'do' the art. Art is always slightly beyond writing. At its best, art

writing can talk with the art object rather than pin it down. This means that those definitive accounts of art – the most widely read one is Gombrich's *The Story of Art* – are not definitive at all. Gombrich's book is *a* story of art, it is not *the* story of art. Anything that anyone writes about art is just one story about art: it is not the right one or the wrong one, it is just another one. I think some of them work for me better than others. And they all add up to create that whirlwind in your head that's waiting for a bit of art to come along and activate it all. And then what? Well, nothing really. You can move on from the piece of art, you can write about it and try to convey something you felt about it, you can even buy it. That's about it. Oh, and if it stays with you, well it has probably changed your outlook on life a bit, or if not your outlook, something or other within your head.

Right, enough of this high-fallutin nonsense. Let's get back to talking about me. Another memory from my Courtauld days: I can remember sitting in the grotty basement that passes for a student common room, when somebody on my course asked a group of us which painting in the National Gallery each would choose to meet a date in front of. Everybody came up with sparkling and amusing answers. I ducked out. I realized that I could not recall any of the paintings in the National Gallery. This troubled me. About a week later, I sloped off by myself to the National Gallery and went around it, trying to choose a painting with which I could have answered the question and then trying to memorize the title of that painting. It was not easy. First, I could not work out if I liked any of the paintings. I had discounted the Impressionist and post-Impressionist stuff because that would have been an obvious, but wrong answer. Wrong – because they do not really belong with the rest of the National Gallery. I was sure that when the question had been put, the subtext was, which *old* painting would you choose to meet your hot date in front of. The problem was that none of the old stuff was really doing it for me. I

tried to choose a couple more or less at random, but then I found out that I couldn't remember their titles.

I gave up. For a few years afterwards I assumed that my problem with old paintings was precisely that; my problem. I had never really warmed to much old stuff – some of the Velazquez pictures in Madrid were cool but that was about it. And then, after a while I stopped really thinking about it. It came back to me earlier this summer at the Venice Biennale. After a few days of non-stop partying, drinking and eating increasingly convoluted canapés, one morning I thought I would try to cure my hangover by visiting one of the city's museums of old art. I bought a ticket and went in. With the first few paintings I saw, I tried to convince myself that this was exactly what I needed. That they were interesting, calming and beautiful. Unfortunately, I rapidly began to realize that this was far from the case. The paintings were ludicrous. None of them was doing anything for me, and I was starting to feel sick. And to cap it all, the place was filled with people looking at the paintings, shaking their heads in wonder and muttering 'marvellous' in whatever language. Walter Benjamin (another Marxist) had a great theory: that paintings develop this 'aura' around them and deluded members of the public treat them like religious objects. It is a hangover from when paintings were religious objects. The problem is that, now they are not, people still cling onto the reverential attitude. I felt like shouting: it is just a bit of oil slapped on canvas.

As I have said, the old stuff has never really done it for me. It bores me. Much of it looks silly. I am not particularly interested in biblical stories, brushwork, light or making realistic images of the world, although I have grown to like weird perspective games and the sheer melancholy of Dutch still-life. This is especially because when I see Dutch still-life, I am usually in Amsterdam, out of my tiny mind. But

the key thing is this: over the years I have come to realize that it is not really my problem at all. These works don't speak to me – it is their problem. Or rather it is a problem with the works and with the writing around it, which usually is dull. And it is a problem with museums, which are too pompous and overbearing. An academic called Irit Rogoff has pointed out that traditional art history used to be overly concerned with the concept of 'the good eye'. This was supposed to be a bit like a vintner's tongue. Read enough boring books, go to enough dull lectures and hey presto – you grow a good eye. Or rather your no-good eyes turn into good eyes, able to enjoy the finesse and delights of old art. Now, this is one of the most enduring and most damaging lies of traditional art history. And Rogoff is right: there is no such thing as a good eye. You can read all the books in the world, you can watch all those terrible art programmes on television and you will not develop a good eye.

So that's about that then. I have not got a good eye, I think most old art is nonsense, but I love Dutch still-life and Velazquez. The point is this. Art does not work in the 'good eye' way. Neither is it good for you in some easily quantifiable fashion. You do not have to have to be part of a secret club to get something out of art, old or new. Depending on what you bring to it, art might work for you. The best advice I can give you is what I said at the start: ignore the rest of this book. Chuck it away, leave it on a park bench. Go and look at some art. If it does not do anything for you, go and do something else, or perhaps go and look at some other art. And like I said, when you find something that does something for you, try to find something written about it. If it is dull, throw it away. Try to find something else. Forget about questions like: 'Is this art?' or statements like 'My six-year-old could have done this'. The answers to those are 'yes' and 'no, she could not'. Art is fabulous. And the stuff you don't like, well, no one is going to force you to look at it. Enjoy!

Essay Three

SOMEBODY'S GOT TO DO IT
Pavel Büchler

Is it possible, all things being equal, to think of modern art as a socially meaningful mode of engagement with the world and with one another, independent from the institutional framework of culture? Can there be art in contemporary western society, without the institutionally sanctioned divorce between the roles of production and consumption, supply and use, making and reception? If art is a form of social interaction, a mode of enquiry directed towards understanding others, is it not futile to insist on any definitive formal requirements for the production of art? And if so, who needs artists?

In *The German Ideology*, written in 1845/6, Karl Marx famously imagined how, one day, society would take over the organization of the production of life's basic necessities, the division of labour would be abolished and he would be free to 'hunt in the morning, fish in the afternoon, rear cattle in the evening, criticise after dinner... without ever becoming hunter, fisherman, shepherd or critic.' If, from a vantage point at the doorstep of the twenty-first century, such a bucolic idyll seems an unlikely prospect, it is not only because the social revolution, as Marx envisaged it, has evidently failed to deliver its promise or just because the pastoral image is at odds with the techno-scientific bias that has largely fuelled the imagination of change in the material conditions of life since Marx's days, but because, in our culture, the forces of social and economic emancipation also bring about a crisis of identity and purpose.

Marx does not say that every sphere of work is commensurate with every other, only that all human activity and potential should be more than a means to an end. In his vision, it is the shackles of having to *be* what you *do* for a living and having to remain so if you do not want to lose your livelihood, that hampers the development of 'what men ought to be'. Being trapped in 'one exclusive sphere of activity' makes every individual hostage to the interests and conflicts arising from the production and distribution of economic surplus. A better society, Marx argued, would refuse to perceive the individual as, at once, a component and a function of the machinery of work whose every action is constrained by its direct economic utility. Having been freed from the perpetual submission to immediate economic imperatives, people would pursue their own temporary creative and emotional objectives without hindrance: 'one thing today and another tomorrow.' As for art, in such a society there would be 'no painters but only people who engage in painting among other activities.'

We now live in a world characterized not by communities but interdependent industries and economic 'sectors', not by diversity of roles but by diversification of means, not by 'useful work' but by the criterion of 'competitive advantage', not by the distribution of surplus but by overproduction, excess and redundancy. Our immediate interests in one another are, to some degree, motivated and maintained by the considerations of the specific characteristics of the professional and economic identities of our neighbours (in the sense in which it is useful to know a good lawyer or to have a friendly joiner in the neighbourhood when, for instance, the community is gripped by an urge to improve the local playing facilities for its younger members). As a society, however, we rely on increasingly sophisticated systems of synchronized performance supported by a uniform infrastructure of communications which have no direct bearing on

individual goals, interests and aspirations (although we characteristically pay lip service to the individual economic identity in such terms as 'stakeholding' or 'ownership'). Our dependency on coordinated, systematic expertise within the agencies of the state and the market has reduced the former certainties of our productive participation in the social world – our 'professions', 'careers' or 'trades' – to patterns of disparate approximations, and 'hunting', 'fishing' or 'criticism' have become mere categories of detailed instrumental procedures, operating routines and specialist know-how. It would seem that under such conditions 'being an artist' can hardly mean anything very much – or that it can hardly mean anything much more definite than 'being an executive', 'consultant', 'contractor', 'sales representative' or any of the dozens of such provisional generic denominations. Why is it, then, that the singular artistic identity ('the artist') should be so contentious and so contested?

What makes it difficult to negotiate the identity of 'the artist' is the widely held view (shared and promoted as a principle by many in the artistic 'community' itself and latently supported by the dominant models of art education) that modern art is functionally autonomous: that it *necessarily* exists at a distance from all other practices. And further, that the practice of art can only make sense of and in the world, as much as of and in itself, from this irreducible distance. Only when it can keep faith with the human and resist being dragged into the social, when it resists the commodified practices and forms of mass culture and corporate enterprise which drive the human and the social further and further apart, can art perform, indirectly, any critical function.

Whether this view is underwritten by those philosophical ideals which see in art an antidote to instrumental rationalism, or conversely, whether it is founded in the notions of 'objective'

aesthetic enquiry which has largely governed the quasi-scientific modernist paradigm of formal plastic and pictorial experimentation; whether it comes from the idea of a seamless continuity of art, its 'transhistorical' nature among the constant flux of everything else; whether it reflects something of the paradoxical logic of the avant-garde tradition by which bridging the gap between art and everything else demanded a negation of all given norms; or whether, finally, it acknowledges the avant-garde's historic failure, the view that art can only function as an autonomous practice always casts the identity of the artist in the terms of self-determining difference.

Self-determining and self-justifying but not self-evident. 'The artist' is always a generalist (for art is an abstraction and each artist's practice is a model of art). Sure, there are 'painters', 'sculptors', 'photographers' and others who describe themselves by a reference to their use of particular materials, media or techniques, or by the nature of the objects that they produce. And it is true that these descriptions are commonly taken to mean specialist activities in the field of art. But this is precisely the point. 'Being a painter', for example, clearly implies the pursuit of certain activities within certain norms and traditions which distinguish the work from, say, the pursuits of photography or fishing, but the application of paint on canvas has no necessary connection with art. It is neither the 'aesthetic quality' of the work, nor the natural gifts of the painter, nor skill, nor, in itself, the tradition of pictorial art, which distinguishes 'the artist' from 'the painter' (the distinction is, of course, non-hierarchical and the question of whether a painter is *also* an artist is not the issue here). 'The artist' is not, strictly, another name for a maker of paintings even if 'paintings' are thought of as a universal self-defined category of aesthetic endeavour – and much less if they are seen against the background of the actual history of painting. The paint, the domain of the painter, is the simple truth of painting. The domain of the artist is

the surplus, the rest, what remains to be seen after the simple truth has been told: the *difference* that art makes. If it is to be found in the painting – or exclusively in the painting as some would claim – then it is in all probability the property of the painter (of the artist *as* a painter); if it resides elsewhere, as others would have it, in the act or context of reception, for instance, in the destination of the work, then why should we attribute it to the painter? Why not say that it is the viewer who is then the producer of art (the artist to the painter)?

If only it were so simple! As the strategies of modern art so often call into question the functional status of artistic practice itself, the overt distinctions between the production and reception of art, its source and its destination, become unreliable, as do those between the work and the institution of art or between the latter and the 'public domain'. The course of action through which the artistic intent is channelled, realized and recognized becomes unpredictable. There are no longer any safe guidelines for the forms of engagement with an audience, as indeed there are no definitive formal requirements by which the 'simple truth' of the work could be established with any degree of certainty (and whose absence perennially provokes among some onlookers the perplexed question, 'But is it art?'). Hence if there is anything left in the work from which, always with a difficulty, the identity of the artist could be derived, then it is the uncertainty of the difference in the work of art, in art as *work*, in how art makes a difference, that remains the only distinct feature of 'the artist'.

When the German artist Joseph Beuys insisted a quarter of a century ago that 'everyone is an artist,' he did so to make us reflect on our collective conditions and individual human potential; on how we live and act as individuals and as social beings and how we could or should live and act otherwise. He did not propose that everyone makes works of art. And when the Austrian poet and Beuys's contemporary,

Hans Artman, announced as a 'well-known fact' that 'to be a poet one no longer needs to write poetry, or even be able to read and write', but that 'a more or less conscious intention to make a poetic gesture is enough', he tried to challenge the definitions of poetry and its ties with the productive/receptive institutions of literature and literacy – he did not dispute that the *realization* of the 'poetic gesture' would still amount (more or less) to making poems. Removing the object or gesture of art from the interplay of difference, or reducing them to nothing that can be materially demonstrated, would silence art as well as liberate it. The idea of artistic freedom, which already provides for such a possibility, would then be fully subsumed in the ideal of human and civic freedom. But what if Beuys and Artman's statements are, above all, works of artists (they made them) self-conscious of their own 'impossible' condition? What if they were acts of resistance to being what the artist has to be?

While the production of works of art remains the main characteristic of 'being an artist' in the accepted sense, as well as the main pretext for the popular acceptance of such a category (somebody's got to do it), it does not provide us with more than instrumental definitions ('artists make art', 'art is made by artists'). It does not justify the existence of the artist or suggest a particular critical function in the social world. It makes the artist's labour 'useful' in sustaining the industry of art, which, in turn, is of 'use' to other industries; it reconciles the production of art with the product of art and aligns it with the value systems of a market (or 'the market' – there seems to be only one). The only difference is then the precise and demonstrable difference between one work and another, one practice and other practices, the diversity of production indifferent to the difference of art. This difference, the variable quality of all art, its transformative power, is what the artist must try to realize (both to understand and to make) by continually testing the conditions of the

production of art as a means for acting upon the world, even if in the materiality of the work of art and the reality of production such an ambition must always end in a compromise – a compromise between making something and making something happen. The social significance of 'being an artist' lies in the artist's determination to resist the identity of a producer, even if that is the only identity that the artist can have. 'Being an artist' then means not doing different things than others do, but doing things differently.

Modern society undoubtedly needs creativity, critical imagination and resistance more than it needs works of art. It needs artists with their ways of doing things more than it needs the things that they make. It needs them for what they *are* rather than for what they *do* – and if it does need them for what they do, then it is in the sense in which artists are producers of culture rather than of discrete artefacts that characterize that culture. The society largely relies on artists to be agents of culture who provide an index of human experience as well as a critical support for social practices and ideologies from which the concepts of culture are developed. And here again, it is the work of art, the actions and consequences of art, rather than works of art, that is the active ingredient of culture. I use the word 'culture' here in that time-honoured sense of the term which associates it with the symbolic and expressive side of the collective human life and relations, as a matrix of conventions through which people share and develop their mutual understanding and their attitudes towards one another. I also use it in that generalized sense in which it is possible to speak of culture in the singular without claiming that there is one unified, overarching culture, but simply because there is, in this world, a continuity among the many individual symbolic and expressive systems, cultures and subcultures, that coexist and confront one another in society, just as there is a continuity among languages or systems of communication.

This notion of culture, 'our culture', endows the artist with a double identity. Artists exist in the society as experimenters with the conventions of culture, licensed by tradition and consensus to define their practices, their particular criteria, specific methods and aims, independently from the dynamics which drive the change in the conventions that prevail in that same culture generally. At the same time, the existence of the artist is also something of a social experiment in itself, subject to the authority of conventional assumptions, beliefs and expectations, as much as to the apparatus of enterprise and economic selection from which the practices of art are expected to stand apart. Thus, on the one hand, each individual artistic practice, each model of art, is by definition unique and non-representative of the culture at large. While on the other, all artists and their practices share in the eyes of the public certain common externally identified characteristics and traits (creativity, critical imagination, resistance, for example) and these collectively represent the place of art in the make-up of the society's self-image. The image that the society has of itself as a culture is then less the product of artists' individual experimental efforts – their works, propositions, observations, statements – than it is the outcome of the society's attitudes towards the value of the artist's 'non-representativeness', manifest as the diversity of practices, for the social experiment of art.

This applies equally whether we conceive of art as representation, a picture of the world, or as expression, a subjective statement of the artist in the world. Whether 'the world' is the outer reality in which the artist partakes with others through observation or intervention, or whether it is the subjective inner world of private experience, it is always *this* world (there cannot be any other) that art acts upon and in which the transformations of art take place. Either way, the artist is expected to provide a private response that is at once non-representative *and* representative of the culture's concepts of art. To

achieve this, the artist must assume a particular position (perspective, point of view) within the 'others' world' or let the others enter the intimacy of his or her unique 'private world', while also maintaining at all times the necessary distance (speculative disengagement) that is needed to understand the artist's practice as a model of art. Art is a game where the rules are entirely made of exceptions. The artist is expected to act as an independent agent of direct experience as if that experience was a denominator of general principles *and* to exemplify general principles as if they were socially authentic departures from the norm. The friction between the two requirements grows with the rising levels of mediation that are characteristic of modern social formations. The more this world becomes the 'world of information', or the more culture becomes identified with integrated networks of distribution and communication of the 'culture industry', the more remote, indirect and abstract the models of art become; the better synchronized the links between the individual and general interests and the greater the dependency of social contact on social institutions, the more the society tends to learn about itself not from the observations of artists but from observing the artist.

The development of 'socially active' models of art is then taken over by intermediaries who 'deliver' art to the public, or who facilitate public 'access' to art – curators, critics, producers, administrators – and whose role it is to negotiate the practical and ideological terms and conditions of the 'services' provided by artists in the society (as much as it is to serve the institution of art). This 'resolves' the troubling questions of the place, function and identity of the artist, by proxy: the preferred form of all social engagement today.

It has been said that art is a job that no one has asked you to do. Yet in the reality of this world, the artist has to gain a special mandate to do it with any sense of purpose. This mandate, the

'artistic licence', stipulates what artists may do. To earn it, however, the artist must make a difference: do differently what all artists are permitted and able to do – indeed what anyone could have done but nobody did and what was thus left to this one artist to do. To find out what needs to be done, the artist uses the 'artistic licence' as a kind of a passport into the social world. The artist is always an itinerant, a messenger and an explorer, who operates in or among others' territories. The artist comes and goes, takes away and brings back. As an itinerant, the artist always remains a stranger whose temporary presence disturbs and contaminates the familiarity of the place. But that presence as a stranger may be just what it takes for you to feel at home.

Essay Four

SERVING A DIFFERENT GOD
Andrew McIlroy

How to bring art and everyday life together is the concern.... we
have put all this art in one little corner.

> Satish Kumar, in *Conversations Before the End of Time*
> by Suzi Gablik

In Florence city centre stands a remarkable building, containing an
even more remarkable work of art. The Church of Orsanmichele, which
stands at the commercial and political heart of the Renaissance city, is
an odd, square building, whose shape reflects its original function as
both grain market and public forum. Once, the four sides of the church
stood open in a busy arcade of merchants, noblemen and peasants who
gathered there under the watchful eye of the confraternity, or guild as
we might call them, to conduct their business, gossip and pray at
Orcagna's marble tabernacle and its votive image by Bernardo Gaddi of
the Virgin and Child adored by Angels.

Today one views the tabernacle and the painting with a certain
detachment; the forms, the colours, the not always very accessible
symbolism of the sculptures and images. The original ambiance was
very different. At the close of a long day of business, members of
the confraternity would gather in bright robes and proceed to the
shrine, carrying candles and accompanied by the farmers and
tradespeople. There they would be joined by semi-professional
musicians, wearing costumes of angel and cherubim, who would

play both courtly and popular songs of praise to the image. The attendant crowd, moved to devotion by the spectacle, would be solicited for alms and contributions, which were then ceremoniously carried up through a staircase in the tabernacle to a small treasury, where such donations were kept. During times of penury or want, the confraternity would distribute money to the destitute and the lame, as a gesture towards the salvation of their own souls as well as the maintenance of peace and stability in the city. The votive painting of the Virgin and Child became thus one of the great loved images of Florence and the surrounding countryside, a source of civic pride and public adoration.

This story served as a cultural epiphany for me. It opened a small window of insight into not only the function of the artwork for its original audience, but also a renewed way of thinking about art for our own weary, post-modern society. Note, I say a *renewed* way. We do not have to reinvent a philosophy of art, rather to rediscover a relationship to art that challenges us fairly and squarely in terms of what a piece of art *does*, as much as how good that piece of art is. The Orcagna tabernacle story clarifies certain dissatisfactions that I have often felt with the enormous cultural infrastructure that surrounds us, and to which I have had frequent and privileged access. That dissatisfaction might be summed up by one word – relevance. Or, more worryingly, irrelevance. Why bother with art at all? What is it for? What can the justification be for all this art machinery when so much of the other machinery upon which we rely (health, transport and environment) is collapsing around us? And, when art disappoints, as it often and glaringly does, what possible relevance can we construe that will validate the experience? Is the ultimate criterion of success only aesthetics? Can we rely only on the responses of the literate and the cultured?

I feel I now know what the Orcagna tabernacle was for. I have a sense that the work lived in some real historical environment and that it worked on its audience an effect conditional upon, but not limited to, the genius of its conception. My pitiful discovery is that even were the work mediocre, the 'installation' or 'happening' had deep value for the audience, fulfilling a practical, a religious, a political and an aesthetic role. And one proof of this is the value which contemporary audiences lent a not dissimilar work, the Madonna of Impruneta, which was itself treated with reverence, attributed spiritual power and afforded ritual respect. This second work has been consigned to an art aesthetical dustbin as it were – *but its value to its society was just as great.*

How distant this engagement seems from the apparently valueless (although often critically acclaimed) experience of much of the arts today, from our soiled beds to our staged infant rapes, from our plush lined stall seats to our corporate crush bars. Where does a valuable engagement with the creative act lie, when art has become merely a consumer product or in Naomi Klein's phrase 'a brand extension in waiting'? James Hillman, the psychotherapist, states this concern with force in Suzy Gablik's book, *Conversations Before the End of Time*: 'How do we find that which art should serve? It's already in service – in fact it's in yoke – to the commodity-museum-gallery ethos, behind which is our consumerist god, the bottom line god. The other god it serves is the self. Art *is* in service, so could we perhaps change that to which it is in service.' Who are these different gods? And will the artist embrace them in distinction to the unique call of the individual genius, the artist unanswerable to society, true only to his or her own dictates?

I take it for granted that creative excellence must lie at the centre of the artwork (although I am less comfortable with the decision-making

processes which define it and recognize it). Art, heritage and creativity must pass the aesthetic test or no intellectual manipulations will save them. But why, once passed, do we remain unhappy talking about the social, economic and environmental effects of the arts? On these grounds alone, the arts should be central to our national debate and not, as they currently are, peripheral.

The arts after all are educational, both in and outside the classroom. This education is both technical (to draw, to paint, to play) and moral (to feel, to evaluate, to see and hear). Our current curriculum obsessions have erased the arts as a standard provision, ironically at a point where it has become clear that purely technical and scientific educational goals do not fulfil either individual or societal needs. There has been a huge growth in non-state arts education in Britain over the past 20 years, plainly filling gaps left in the curriculum. Too many children today are deprived of the opportunity not just to become performers, but also to become audiences.

I can thank the (frankly) lacklustre training I received in art, in music and in drama while at school for much of my adult social and professional success, for seeds were planted when I learned to play 'Greensleeves' on the recorder or embarrassed myself as Professor Higgins in a smoking jacket many sizes too large. Sad to say I would not have had the opportunities to sing, play and act today that I received 20 years ago, when my parents could not pay for them. The middle classes can afford to recognize the arts for their role in promoting interpersonal skills, aspiration, creativity and risk taking of their children where others cannot. Increasingly, a cultural apartheid is being created that reflects and perpetuates the economic silos we have been building since the early 1980s.

Of course governments recognize that the arts are economic motors. We drown in the related rhetoric. The arts and cultural industries are

the primary earners in Britain. Without theatre, gallery and cinema, London, Manchester and Glasgow might as well shut up shop. In Britain, music exports have been bigger than those of engineering since the early 1980s. In the USA they contribute more to export earnings than aircraft manufacture and employ a much greater percentage of the population. In London, Milan or Berlin they provide three to five per cent of the workforce.

Statistics. What a bore they are. They cannot give any sense at all of the difference between a Brighton city centre street, lively and chaotic with ideas and people, aggressively diverse and yet infectiously welcoming and empowering, with the greyness and disenchantment of some of our other towns and cities. Our future economic success depends on the arts and cultural industries as the drivers of innovation, of product development, of industries such as the audiovisual, the graphics or the hi-tech, but there is still precious little crossover of awareness between the start-up techie and the contemporary dancer who lives in the same street. If there were, we might see the odd cheque being written by the DTI (Department of Trade and Industry) to fund art colleges or multimedia spaces. The arts themselves are almost as narrowminded of course. Most artists, from high to low, prefer to sit in their towers. The crossover artist, the artist who plays with and through their society (and I don't mean those who 'critique' their society via their work, but who engage with their surroundings via the process of their work) is rare and, where they do exist, is usually written off as a 'community artist', which I always thinks sounds as if one were really saying that he's an amateur but still manages to get paid for it!

Take sponsorship, for example. There's not an artist in the land who doesn't cringe on being told, 'Today's arts are a vehicle for business

values', but why should they? What artist has not had a patron? Originally, it was desperation that drove artists into the arms of business, but I like to think in some utopian way that the results of that enforced marriage have been more profound and more valuable than just the £150 odd million in business sponsorship that sloshes around. The relationship between the arts and business has moved on in the best of cases from the empty corporate seats at the first night and the champagne cocktails in the reserved space behind the ropes, to one of the tools of corporate identity and creativity (just as the corporate world is becoming one of the vehicles of the arts to its audience).

I am always amazed that artists can complain that 'art in canteens' is somehow demeaning of their work or that running writing and creativity classes inside business is a distraction from their calling. *We all work after all.* Eighty per cent of our time is probably spent getting to work, at work and worrying about work. It is the major single shared experience of the early twenty-first century European (much more so than the family or spiritual anguish or drug addiction). And yet so little of the arts canon is directed to it. And the place of work is seldom seen as offering a new arts environment in which to engage the worker, who is, after all, the person who on Saturday evening hopefully (in both senses of the term) becomes 'the audience'.

Some companies such as Unilever are taking this philosophy to the limits, by creating entire support structures for the arts inside which the creative and commercial can feed and learn from each other. Project Catalyst, as Unilever call this programme, is not an arts sponsorship programme. It identifies business issues and addresses them by working with artists and arts organizations. Catalyst supports people at work both directly and indirectly by helping them

to develop themselves personally. It is a voluntary programme but over 80 per cent of staff at the Unilever site at Kingston-upon-Thames have participated in at least one event.

We know that the arts are a sound basis for community and identity and this is ever more urgent in the face of social fragmentation. Sometimes this is via the most challenging arts, as is the case with the London International Festival of Theatre (LIFT). While making no compromises on critical grounds, LIFT has developed a language and a system for involvement of the community at grassroots, which has made it a model for engaged arts all over the world. LIFT ended in 2001, which would have been a cause for general despair, had its founders not determined to move on, to find new ways on engaging their audiences in the process of creating and participating. Lucy Neal and Rose Fenton focus not on their 'art', but on its effect, on the *role* of the artist and not only on his or her existentialist condition. It is incredibly invigorating to see this successful project stop, change, move ahead unencumbered by building and structures.

Not that buildings necessarily hold us back: it just depends which buildings and what use they are put to. In Chelsea and Westminster Hospital, for example, arts, both visual and performing arts, have become a vital part of the healing process. And since the hospital is an unconventional and unexpected arts venue, Susan Loppert, who runs the arts programme, has created new audiences for the arts by making them part of daily life for patients, staff and visitors. Chelsea and Westminster Hospital is now home to 1,000 paintings, sculptures, mobiles and a weekly programme of performances including music, dance, theatre, puppetry and storytelling, often by internationally acclaimed artists. The art is excellent, the access unrivalled, the functions and roles complex and varied. Few art critics could put a programme like this together.

My worry narrows itself down to a very straightforward question, one to which I feel we all have at least an instinctive response. Is the whole purpose of the artist to create a beautiful object (a play, a sonata, a silver box), or is it somehow, somewhere accountable? Can art be absolved from *all* accountability? This sense of accountability may be nothing more complex than an agreement that art is rooted in a particular social, economic and scientific situation or it may go as far as to claim that art has a social function and that this function is quite as much part of the artwork as the paints, lighting or language that make it.

There are many defenders of the contrary position and they are often unfairly tarred as purists, when in fact they are merely idealists. John Tusa, in his book *Art Matters, Reflecting on Culture*, clearly and rightly believes in the supremely civilizing potential of great art and the public purse's corresponding duty to provide significant subsidy, even for performances enjoyed by only a tiny and comparatively wealthy elite. We should be clear that this is a justifiable intellectual position. It just is not one that works. Art matters in lots of ways and the Royal Opera House is one vital (but relatively small) piece of the picture, rather like a flash of gold thread on a tapestry.

What works in terms of arts policy (and surely government and voters have a right to expect an arts policy since they have a responsibility to fund arts practice) is multifunctionality, the jigsaw of social functions wherein aesthetics and civilizing mission do have a role to play, but do not necessarily get all the best monologues. Belinsky, the great Russian critic, wrote in 1846: 'To take away from art the right to serve the public interest is not to elevate it, but to debase it, because it means to deprive it of its own most vital force – of thought – and to transform it into the object of some kind of sybaritic enjoyment, the plaything of lazy idlers.' It is around these

social functions that we must gather our ideas, for the danger is that they will be imposed, when they might just as easily be embraced.

Oh, but I hear the subtle knife being drawn. 'I allow you all of that,' the connoisseur might say, 'and so much the better. But it is not enough. And I will not allow you to construe worth and much less argue for priority on the basis of values which are antithetical to a more noble endeavour, which is the service of beauty for beauty's sake and arts for civilization's sake.' And yet we prioritize all other areas of civic life, don't we? How did the arts escape that burden?

The problem is that most art sets itself up as the only measure of its own value. If the piece is good, the experience is worthwhile. If the piece is bad, then the entire experience has been a waste of time. Let us consider the Tate Modern. What is the building if not an 'entire art experience'? Can the works that hang therein be disassociated from the environment that hosts them, or the social and economic framework within which they sit (just like Orsanmichele)? Critics have loved to lambast the Tate Modern for the fact that its collections do not perhaps live up to the envelope, ignoring that the building affords a smashing visit to someone who is not the arts critic of the *Observer* and yet has an interest in or unguided enthusiasm for the visual arts. And the fact that the Tate Modern is regenerating its local community, providing cohorts of jobs, attracting millions of tourists and contributing very nicely to the treasury, thank you very much, is at best a justificatory response, one that smoothes over the exquisite disappointments about the hanging policy, when these should be the very things we are celebrating.

I see no reason not to view the arts of today within the complex machinery of society. I see no reason not to attribute value to the work of art on the grounds of its social or psychological resonance.

Why, at its most extreme, should not the funding be considered as part of the work of art itself? Why should not the commitment of the banker, the uncertainty and skill of the sponsor, the leap of faith of the chief executive, the arts officer or the local council that gives £50,000 for the creation of a pair of sculpted legs to adorn the swimming pool forecourt not be recognized as an essential element of the overall experience? Great art has indeed the taste of life about it.

Those of you who have followed me through to this point will by now have realized that I made a deliberate error in the first part, when I implied that Tracy Emin's *Bed* (has so much cultural luggage ever been loaded unto so fragile and dishevelled a support before?), Mark Ravenhill's *Shopping and Fucking* or the Royal Opera House crush bar have no function. It is only that their functions are currently too narrowly defined for my taste.

Isaiah Berlin in his essay *Artistic Commitment* says: 'The protest of the artist was against attempts to harness him to some extraneous purpose he found alien or constricting or degrading. After 1830 it takes the form of a vehement outcry against the commercialisation of art, the domination of the bourgeois consumer, the conception of the artist as a purveyor for a mass market.' A lot of good it did them from the perspective of twenty-first century cultural commodification, for 170 years seem not to have changed the terms of the debate. High Art is still difficult to reach. Community art is only art for the poor souls who still need communities.

We have a New Labour administration stretching out *ad infinitum* in front of us and in spite of all the comforting noises they have made, and indeed the comforting cheques they at times have written, there is little sense yet that they will grasp the chance to bring the arts in from the margins of our national life. Tony Blair has said that his

political agenda is to 'define a new role for collective action... which advances the interests of the individual.'

What lover of culture could want for more? What is the cultural experience if not the exquisite synthesis of collective energy, a shared experience and the intensely private moment? What could be better than culture to communicate common values, with respect for individual difference? Who better than the arts to reconcile us to a new role in Europe and in the world, that is not forever harking back to past glories while missing the present opportunities? But if there is a possibility for such a collective *prise de conscience*, who will lead the battle charge? The arts and heritage, central to the political and social apparatus of so many European counties, sit at the fringe of attention in our national life, pushed aside by sport, by celebrity and by juvenile politics, isolated by a critical language that seems to understand only part of their varied value. It is interesting to note that in the UK the only place where the two main parties seem not to differ much is in their arts policy. They never articulate the differences, for who is supposed to care?

There is an inevitable multiplicity of functions for art, some of which offer us new ways to see ourselves and our communities, some of which lift us out of ourselves and into a contemplation of our humanity, some of which are failures, some of which are about jobs, money and better parking facilities. Some of these functions may be terribly banal, just as clean toilets can be just as important to a successful theatre experience as the generation's greatest actor on stage. We should not be afraid, however, to speak out all their names. Indeed, I believe we should be constrained to do so.

Essay Five

ART: AGENT OR AESTHETIC?
Aidan Campbell

Art is good for stretching the limits of the human imagination, but it can also internalize and reinforce those limits. Art's wonderful vistas and ghastly dystopias can provoke incessant deliberations on the unknown, but the same imagery can also be used to moderate such fanciful exuberances. Art challenges tradition, but it can also devise tranquil reposes or repulsive effigies which help buttress convention. Works of art – whether tribal idols, legendary monsters, religious icons, coolly classical proportions, romantic idylls or political symbols – can console or terrorize as required.

Whether carrots or sticks, images are effective weaponry in the armoury of social engineering. So are we inquisitive beings always dreaming up artistic fantasies and trying to realize them? Or are we basically complacent people who use images to fend off disturbing novelty? Contemporary art seems distinct from both these definitions. Present-day society has abandoned the notion of conquering new frontiers. But it also repudiates retrogressive heritage, especially the vile legacy of fascist culture. What is art good for today?

A dynamic civilization values the productive collisions of imaginative symbolism and abundant materiality. Traditional values are partial to tangibles like bloodlines and land, wealth and possessions. For its part, contemporary society is a flexible image-obsessed culture, inflexibly opposed to all objects. Vicarious rather than visceral, the

protagonists of contemporary culture celebrate the mind. This cerebrally oriented artistry prefers motion to inertia, yet it only goes through the motions of being mobile. A portrait of rapt immobility before an ever-flickering VDU screen springs to mind. Extolling objects and worshipping the perfectly beautiful body are excoriated as either macho or fascistic. The repulsive complacency of organic materialism has been replaced by the indolent virtuality of style.

Contemporary culture is just as quiescent as traditional heritage; it is just that it is image driven rather than materially oriented. Even after 11 September 2001, being creative means living imaginatively while disparaging corporeality. Unleashing animal physicality to confront obstacles is frowned upon. You alter your identity to deal with problems. The cornucopia of cultures that comprise the modern lifestyle agree on at least one thing: they object to objects. When materials must be used, as in sculpture, they are granted the status of honorary symbols. Likewise, architects engage in an undignified scramble to get their buildings and bridges declared works of art. Sacred relics dredged up from the past are patronized in playful pastiches. Cultural experiments with images are welcomed as far safer than scientific experimentation upon things.

While there is little support for the censorship of images, all kinds of objections are raised to physical relationships. Mass advertising is furtively enjoyed; mass consumption is fulsomely deplored. People's material needs are thought best met by the vacuous concept of self-esteem. Contemporary life has a passive demeanour remarkably similar to that of smug tradition. At the same time, however, it is a mistake to presume that the conceptual mentality is incorrigibly lethargic.

It is a caricature to view the modern individual as a couch potato. On the contrary, people work overtime to produce and to consume

vast quantities of motifs to offset their anxieties over physical contacts. The contemporary esteem for imagery is not escapism. It is the socially approved way to engage with the modern world.

Our risk-conscious political establishment finds the subversive contemporary art scene appealing because of its mammoth capacity for image creation. These days the establishment cultivates antipathy towards objects because it has recently decided that the unlimited development of modernity no longer suits its interests and it is modernity that manufactures things. The image-producing arena of culture has swollen in consequence. Devoid of political solutions with which to legitimate itself, the system now feeds on radicalized art to preserve itself.

Back in the 1960s, French 'Situationist' Guy Debord cautioned against the development of a Society of the Spectacle. He saw adverts as the evil emissaries of a rapaciously exploitative state. Debord suggested that the only way to overthrow capitalism is to beat it at its own game and deploy subversive imagery in high-profile 'situations' or stunts to debunk cherished symbols of authority. This is dodgy reasoning. Bishop Berkeley's absurd conceit that concrete reality is just a delusion has not suddenly come true for our image-obsessed age.

Modernity has not transmogrified itself into thin air. It is rather that our industrial world has swung round to privileging imagery above menacing matter. Far from careering towards materialism, the market and its consumers have swung the other way and become idealized. The millennial establishment can therefore accommodate Debord's seditious signage. The much-maligned advert is now conceived as a friendly and flexible device, as ironic commercials compete to profane the toughest commodities. Even nature-loving

environmentalism has been affected by this cultural shift against matter. Traditionally, Greens have castigated the cities for polluting unsullied Nature. Modern city-living ecologists, however, put far more effort into rebuking country dwellers and tribal peoples for failing to conform to their artificial image of the eco-warrior, the contemporary version of the Noble Savage. Urban life, for its part, is looked upon with ambiguity by the contemporary sensibility: it is damned for exacerbating the dangerous materiality of Nature and celebrated for providing a site in which to display our lavishly constructed identities.

The minor tensions that occasionally flare up between Greens and downtown fashionistas can be reconciled through the project of designing a myriad of styles for those identities, because they both agree that materials have become objects of suspicion. This novel aversion towards matter is not the result of a sea change in the nature of matter itself. It has not all suddenly become as dangerous as a radioactive isotope. It is rather that the authority of imagery is ratified in general by demonizing matter. Likewise, artists and designers are deemed to be the model individuals of contemporary society. Every career tries to get designated as artistic these days. Even the economy has relabelled itself the culture industry.

Contemporary culture is a vehicle by which a discredited political system hopes to reach its disaffected youth. Our society is puritanical towards materialism. Yet shock art makes that same society look brashly outrageous and therefore inviting. Art is transformed from an occasional visual experience into a permanent lifestyle. Radical art's outlandish spectacles confirm that matter is threatening while imagery is exciting. In the abstract, any art form should be appreciated in a world devoted to celebrating imagery. In reality, by stoking up anxieties against physical relationships, contemporary art realigns itself as an agent of social engineering.

Consequently, art has formed a hierarchy of images to grade motifs according to their disposition towards materiality. Nazi symbolism and racist graffiti are loathed the most because they depict all people as objects, with whites possessing the most superior biological organism. At the other extreme, the summit of positive imagery is occupied by portraits of victims of genocide and especially the Holocaust. At the 1997 *Sensation* exhibition, the Chapman brothers were denounced for producing an installation that allegedly gave comfort to child abusers. They were rehabilitated when their *Hell* (2000), comprising nine concentration camp scenarios arranged in the shape of a swastika, was proclaimed as great art by a number of influential critics.

After fascist symbolism comes pornography, closely followed by any sensuous pictures of women. From the 1970s, such bill posters had 'this image degrades women' scrawled over them. The chief complaint was that they treated women as objects. Women are often presented as victims of a testosterone-driven male gaze. Studies which claim to defy unabashed sexuality are therefore appreciated. When Britartist Marc Quinn's sculpture of disabled model Catherine Long won the £25,000 Wollaston prize at the Royal Academy in June 2001, Long commented approvingly: 'I thought it would be really positive for people to see people with disabilities in that sort of environment.' Quinn has also explained why he believes the human body is more a cultural than a material entity: 'With the human body you sentimentalise matter, because you give it importance. But actually the molecules and the structure is the same as anything else ... It's just purely cultural.'

Following glamour images come 1950s-style commercial adverts that do not display guilt about their fostering the mass consumption of commodities. Just before fellow Britartist Michael Landy

destroyed all his belongings in a piece of performance art conducted in an Oxford Street store in February 2001, he explained he was doing it in order to examine consumerism as a way of life, but he also took the opportunity to warn against 'the black hole of credit and how we are pressured by an infinitely adaptable consumer society.' Sarah Lucas's piece for the *Intelligence* exhibition at Tate Britain comprised two burnt-out cars covered in cigarettes. She later observed: 'Some people, especially smokers, say that the work is a waste of cigarettes – but cigarettes are always a waste, and like all addictions, they are corrupting.'

But for adverts at least there could be salvation: through irony. Cigarette adverts were the first to be given the conceptual treatment by contemporary art. Charles Saatchi was the first patron of the Britart generation and his seminal Silk Cut adverts in the 1970s were notable in eradicating any reference to smoking at all. Instead Saatchi made a knowing reference to a famous contemporary work of art, Christo's 1971 installation *Valley Curtain*. In his version, Saatchi cut through the image of a silk curtain stretched across a valley. Cut silk – Silk Cut. Geddit? As ironic works of art, Saatchi's adverts neutralize the threat posed by the addictive material they promote.

The threat posed by matter is turned into an exhilarating experience by shock art. This artistic catharsis paves the way for more long-standing closure channelled through the agency of therapeutic art. Maya Lin's Vietnam Memorial in Washington DC has become a modern Wailing Wall where anyone can congregate to vent their emotions. The proliferation of Holocaust museums elsewhere serves much the same purpose. Millennial society has commissioned a plethora of public works of art and magnificent galleries. Within their antiseptically white walls, these galleries shield us from their

hazardous *objects d'art* by surrounding them with security guards, alarms and signs warning 'Do Not Touch'. Galleries have been remoulded into vehicles offering to protect us from a world purportedly rife with tangible danger by converting it into innocuous imagery.

The awkwardness that still attaches to this process is due to the fact that a society devoted to imagery must induce an avalanche of matter in order to make this art accessible to all. Reluctant to compromise themselves in the eyes of their young audience by being associated with this conspicuous consumption, the Britart alliance with Britgov known as 'Cool Britannia' soon froze up.

The official obsession with imagery also exacerbated this estrangement. An artist's creativity is a confidential activity, but it is constantly intruded upon by a society intent on monopolizing imagery as a social mechanism. The unregulated individual imagination is far too fickle for the liking of the powers that be. In an era when zero tolerance rules the roost, an image-obsessed society will tend to view its own demise graphically too. Despite widespread approval for radical art within galleries, graffiti artists are persecuted because their unauthorized motifs are perceived as harbingers of social collapse.

In this gulf between art as private impulse and public instrument, current art is increasingly supervised by faceless institutions, such as the National Lottery and the Department for Culture, Media and Sport. Official encroachment on the cultural arena has led to endless prevarication over which statue to place on the empty fourth plinth of London's Trafalgar Square.

The case of contemporary French art is an even more dramatic illustration of this pernicious influence. In the early 1980s, the then

president François Mitterrand inaugurated a policy of funding French art and culture to help Paris regain its international prestige. Mitterrand's money was highly successful in initiating a programme of gallery building and renovation, but otherwise it left French art emasculated. Catherine Millet, editor of Art Press, believes that it is the ready availability of official largesse that is responsible for rendering the current Parisian art scene moribund: 'Everything rests with the state. This makes French art look like official art. Since the Mitterrand years, we have created a generation of noncombatant artists who have settled into a comfortable existence. They say to each other: "We'll get shown and there will always be money".'

It is debatable whether romantic nostalgia for the days of *La Bohème* and its frozen artistic garrets will instigate a revival of French or any other art. Nevertheless Millet's pessimism towards the contemporary scene seems justified. Try to recall the name of any internationally renowned living French artist. You will be doing exceedingly well if you can think of more than three.

The issue at stake here is not whether artists exhibit in galleries or not. It is rather that a society that is hung up about imagery tends to fashion a far narrower range of art than a more indulgent society which, while prepared to fund art, scarcely considers it seriously. Why does art tend to flourish more when we relax about imagery, rather than when we are always compulsively asking what is it good for?

Living on the thin air of imagery advantageously cuts down on the system's expenses. Its subversive poise effortlessly undermines youth's hard-nosed cynicism towards commercialism. But the chief consequence of contemporary culture is the way it annihilates civilization as an appropriate goal of human endeavour. Modernity exalts art, but only after ostracizing it to its margins.

Before modern times, science and art were required to act in cahoots. Under modernity these two aspects of civilization were freed to develop in directions that suited themselves. Although art is common to every human society, organizing art under its own rules – aestheticism – is not. The product of the eighteenth-century enlightenment, aestheticism enabled art to develop tremendously. How so? Industrialization extended privacy from a privilege of luxury into a condition familiar to the whole population. Capitalism was sufficiently confident to fund a privatized sphere of culture that made a principle out of disregarding the wider social concerns of its paymasters. A more rational society no longer required the mystical iconography hitherto provided by artists to the ruling classes.

In consequence, the artistic imagination ranged far more widely (and wildly). For example, although it had existed on the margins of fine art for aeons, abstract art went mainstream for the first time during the aesthetic era. Aesthetic art was worthless, but worthless only in the sense that it was meaningless or irrelevant to everyday society. In the private world of the imagination, in the world of art, the irrational-based aesthetic schools of art meant everything. Just as a line or a circle cannot tell you about the societies that produce them, neither can the aesthetics of neo-classicism, romanticism or modernism directly reveal much of anything about modern society. Stylistic differences among art schools were a highly cultural debate to which much of civilization remained utterly indifferent.

Rather than insist that society make itself congruent with such cultural deliberations, however, the enlightenment confidently assumed that adults could walk and chew gum at the same time. The grown individual could cope with not one but two minds: one public and one private. A person's public mind grapples with everyday affairs and politics; the private one relaxes with the family,

studies art and literature and engages in sport. Neither sphere need be attuned to the other. Furthermore, the rules that governed private life were not the same as those that regulated public life. Privacy was still subject to social regimentation, but of a far more indirect kind. Aestheticism was the obliquely social regulator for newly privatized modern art.

Art can be a force that encourages creative thinking in the audience. But it can also make us complacent. This applies as much to art encased within its own aesthetic system as when it is integrated into society. True, each aesthetic school despised its rivals bitterly. But this rivalry did not inhibit artistic development in the least. On the contrary, it provided the foundations whereby the dominant aesthetic could be superseded by an entirely new visual system – through rewarding the maverick activities of the avant-garde.

These experimental artists would become the comfortable academicians of the following artistic era. Their complacency in turn provoked the formation of another avant-garde, who were equally determined to defy their predecessors by developing a wholly new art style. In this way, aesthetic art developed different styles by itself, and all without waiting for permission from the rest of society. Conversely, aestheticism refrained from exercising direct political sway over society. Academic art never possessed the social influence that Britart enjoys today.

The recent decline of politics has encouraged society to return to the artistic sphere and recruit contemporary artists to the task of meeting the ideological requirements of our millennial world. Likewise, the mature separation of the mind into public and private spheres is being relinquished. We are reverting back into one-brainers again.

The idiosyncratic rules of private life must become compatible with public regulations so that both make sense as a whole. Multiculturalism harmonizes with political correctness. Insofar as contemporary art rejects aestheticism and surrenders its stock of whimsical meanings, it acquires the new burden: that of needing to make direct sense to society instead. Inevitably, this checks the range of artistic meanings that can be addressed in millennial society.

In the past, even the most isolated rustic knew what a crucifix meant. Fifteen centuries of western art produced many different variants on the theme of a divine man hanged on a cross. Good. But we can only speculate on what this enormous artistic effort cost in terms of lost opportunities to develop wholly new motifs. We have already referred to how the bureaucratic channels of public art policy act as a drag upon artistic creativity. The ultimate hindrance to artistic creativity today is the social pressure being exerted on contemporary art to make sense to everyone.

Traditional politics may be discredited, but the rise of anti-matter iconography to take its place has been uncontested. People carp against the contemporary art scene for what it most likes about itself – its conceptualism. Since conceptual art underpins our multicultural society, however, such criticism rarely strikes home. Consequently, critics tend to harass Britartists for their personal foibles instead. Although there is much to disdain about the personalities of Britart, nobody is posing to the likes of Damien Hirst and Tracey Emin the only sort of challenge that would seriously worry them: developing an entirely new art style that would make their own mode redundant. Such a prospect is unlikely to trouble the Goldsmiths crew while conceptual art remains the ideological seedbed of the contemporary political creed. When artists are preoccupied with making sense, they are distracted from readily generating genuinely innovative art.

Never mind what art is good for, the current obsession with it is no good for art. Art is both overestimated and underestimated today. It is overestimated as a practical agent, able to heal or harm at the behest of millennial society's rulers. It is underestimated as an aesthetic, a self-regulating system devoted to the proliferation of images yet confined to the periphery of everyday society. If we treat today's dominant victim motifs as a 'good for nothing' aesthetic confined to the cultural edge of society, rather than shoe horning them into social engineering projects, it may even start to improve. Although this massive output of victim motifs portrays a debased view of humanity, it adds considerably to the visual stocks of civilization.

The explosion of art in millennial society may help undermine the suspicion that sees present-day humanity on a hiding to nothing. But no amount of fine art can overcome the pessimistic view that mankind is morally bankrupted by being affiliated to matter. The notion that matter is repugnant and that only culture matters mirrors the equally false interpretation that culture is a meagre by-product of nature. Both standpoints reflect societies where, albeit in very different ways, dull mediocrity reigns supreme. The marvellous art created by our image-obsessed society ends up insipid because it is used to stigmatize physical encounters. So Tracey Emin's tent which lists 'Everyone I Have Ever Slept With 1963-95' is not just about sex but any close intimacy. The artist claims that AIDS and HIV 'was everywhere in the 1980s' and this knowledge had influenced her piece: 'For me, with the tent, it was important to be aware of everybody I'd been with.'

The frenetic millennial mindset hampers art by consistently forcing it to abuse the real world. Art must be free to range where it will, but if its licence to be irrational is used to police society, both art and

civilization will suffer. Art untrammelled by responsibility may not pay any instant dividends. As it percolates outwards, it embellishes our imaginations.

Maybe that is all that art is good for.

Essay Six

REINVENTING THE WHEEL
Sacha Craddock

'But is it art?' asks the television news reporter pointing to the body of the dead horse hanging from a sling at the entrance to the Tate. While an air of tight-lipped defensiveness insisting 'all contemporary art is a good thing' reinforces the them-and-us atmosphere put out by a large proportion of the contemporary art world, the desire to define what art is, and therefore what it is not, can seriously impair discussion, enjoyment and production. To have constantly to reinvent the wheel and surround the subject with a rather stiff and condescending air of justification is such a waste of time that the question should not be 'Is it art?' so much as 'Is it good art?'

It is always easier to know what you are not than what you are, and most art students start off armed only with definition. 'I didn't make this; I am not that kind of artist, I am not expressive, romantic, impulsive, anti-theory, over-theoretical, old fashioned, obsessed with fashion, predictable, a painter, a sculptor' and so on. Their artistic space is often created negatively, the equivalent of the space between the bottom of a seat and the four legs made solid by Rachel Whiteread.

The Palais de Tokyo, the Musée d' Art Modern, is currently asking the question 'What is the role of the artist today?' for a large, all-inclusive art world book of quotes. This question implies that somehow circumstances have changed enough for it to be worth asking again.

But what has changed and, more pressingly, how do changes in technology, communication and reality, make the position of the artist so very different? The sudden shock of extreme reality triumphing over the unreal, and unimaginable in New York has perhaps rendered the constant need for the artist to claim a greater role somewhat superfluous.

This mapping out of conceptual space is mirrored in the art world at another level. Much criticism is based in the somewhat false repudiation of that which has gone before and so the original art school pattern keeps running. 'Of course I am not one of those isolated artists in an attic, I do not follow the usual model. Instead my work is more real, interactive, relevant, made within the world – not outside it.'

Such claims at the beginning can be grandiose and this has a lot to do with the question of subject, which can shape a work. The bearing a work has to the world is sometimes forced. When the painter Baselitz first started making paintings in his native East Germany he wanted to make art that was important. Baselitz quite literally painted huge pictures of important people; Beethoven, Marx and so on. This relationship with a choice of subject may seem naive, but it does introduce simple doubts about the relevance a work can have and about the equation of subject with effectiveness.

Definition kept everything going before Modernism; the fight between painting and sculpture, illusion versus fact, has been there from the beginning and still goes on. It is interesting to chart the relationship the British art world has had with sculpture over the last 20 years. At one point the sculptural object dominated. It is as if at least Richard Deacon, Tony Cragg, Julian Opie and Richard Wentworth were producing something, though sometimes comical, at least real.

Richard Deacon's sculpture with its rivets and obvious allusion to its own manufacture seemed, on analysis, to make both a conscious and unconscious reference to the demise of the manufacturing industry. This affair with tangibility coincided with a post-modern distrust of the two-dimensional image; while the image was illusion, the object was at least fact. This attitude coincided with a very deep run of conservatism in which notions of accountability and worth became most basic.

Soon, however – and this may be a touch simplistic – the relationship with the image changed. Two-dimensional language became dominant and the object almost embarrassed with its physicality. This owes much to the strong legacy of minimalism, taken to a fine extreme at the end of the 1980s when the very existence of material portrayed the awkward existence of the individual maker. Video, too, the ultimate in its ability to disappear with the flick of a switch, grew in use and effectiveness as an artistic medium. These moves from important to out of date, from relevant to passé, from hot to cold, reflect in part the constant need for art to be relevant. Shifts in approach are not purely a question of fashion, the artistic equivalent of skirts cut high or low, or the choice between 1950's, 1970's and 1980's revivals. They are more complex and powerful procedures.

Things happen at different paces; art exists in one form or another; and yet there is a moment, a frozen representation of thought and form, around which completely different elements revolve. Discussion, comment, understanding and interest are essential to the existence of an artwork and any artwork will be seen differently at different times, but movements in art are now analysed, claimed, invented and rationalized somehow sooner than ever before. Such instant historicization means elements, objects, incidents are immediately defined by their comprehension. It is hardly surprising,

therefore, that art history is seen as irrelevant and cultural studies carries all before it; the self-circular regard of art becomes stronger than ever.

Questions about whether something is art in the first place are usually followed by questions about power; who decides what is seen, who chooses and in what name? These important questions become mixed up with vague notions about 'art for all' and the implication that the people who make the decisions are somehow ignoring this consideration. Again returning to the first example, that of Baselitz and his 'important' people, the relationship between artist and audience is the key.

It used to be considered quite wrong to try to appease the public. Now, often, in art schools and therefore outside, the artist is in a strange role in relation to audience and ideas around intention and reception are so mixed up that he or she is thrown simultaneously into the role of judge, juror and defendant; thinking, making, talking, justifying, stepping from one side to another, inside and outside the process, in anticipation of effect and affect.

It used also to be considered intrinsically wrong for an artist to admit the relationship between money and the art that they make. The gap, or gaps, between everything is closed sooner now. Perhaps a more privileged era allowed the indulgence of independence between cause and effect, object, expression, painting, print, photograph, the audience and hopefully the collector. This relationship to time means that visual language and verbal language are not the same thing. Effect is impossible to gauge, past the question of whether something is good or bad. The way it works will never be determined by the number who see it. Neither is the popularity of a work linked with its function or its effect. It is a waste

of time for those considering worth to police or gauge effect, because time protects, kills the bad, but allows the new and good to evolve and take meaning that is complex.

Discussion around art careers proliferates and this can at times be very separate from a consideration of the work itself. In fact the gallery, the support network, is discussed while the work remains a shadowy notion. So for highly practical reasons the question of who has the power to decide can activate as much fury as the discussion around the art itself. But the relation between deep knowledge and instant experience is highly complex and things do not come from nowhere, despite the claim of a generation of artists that they were never taught and are disinterested in the history of art.

Art is complex exactly because of its perceived relation to the world. While some art is challenged for reflecting only the everyday, the need for drama – almost the caricature of the artistic subject – also persists and artists like Bill Viola and Damien Hirst who deal with death-defying Victorian values, prevail. The fact is that individuals are touched in some way or another; a really young girl stands beside a toy tent embroidered with 'Good Luck Tracey' on the steps of Tate, Millbank on the evening of the Turner Prize Dinner 1999. Emin's work represents only the very edge of a particular genre; a world of self-imposed discipline, rigour, system, philosophy, pastiche, narration, expression and language also feeds the sea of attitude in which her art exists.

It is useful to consider not only the function of art but whether that function has changed. Obviously the old-fashioned, liberal and even revolutionary idea of art being separate in time and space has been replaced with a good deal of attitude about accountability and understanding that the process is itself as artistically relevant as any

idea of product. A tendency, established first in Austria, for 'Social Art', where artists even establish a hostel for the homeless, for instance, or a clinic for prostitutes, is one extreme. It has even been suggested by one particular artists' group that they take a specially designed water carrier to Africa. Here it is suggested that art can change things for real, that artists are the only people to cut through normal procedure. While artists flatter themselves on their potential, business people invite them for breakfast to pass on to commerce the multifaceted skill of making something from nothing.

Time is a major factor; the artwork is caught in a terrible trap of specificity, because it is perceived between the need for an immediate rush, an instant effect and clarity of purpose and the powerlessness of a specific moment or encounter. The powerlessness of art sometimes traps the artist in an unpleasant relationship to the world. It is often the case that an exhibition or event can be a major disappointment, that compared with all singing, all dancing, all virtual advanced digital media, the artwork seems limp; but a gut reaction, 'Is that all there is?', is quickly followed by a rationale of understanding. This has nothing to do with whether something is good or bad, but reflects that the actual experience of an artwork was never the whole point.

A strange contradiction exists here between the fact that affect, or effect, is so important while the actual experience of art becomes more and more secondary. Outside elements, government, public authorities, architects, imagine that art can do a tremendous amount of good. Funding is often linked to subject: a great pot of money is available for artists who make work about science, for instance.

Knowing what you are as an artist can be based on a suspect notion of advance and development. But how much better are *things*? And

whose things are they? People who commission public art (in itself a strange category) are fearful of anything that is permanent or assumes a fixed and shared view. This is about placing art in the reality of existence. The division between the public who attend galleries and museums and those who stumble across art in the public domain is often oversimplified. One of the last portrait statues to be unveiled in London is that to Bomber Harris in front of St Clement Danes, the RAF church in the Strand. This was hardly uncontroversial: Bomber Harris actually bombed Dresden and is probably not in any way a hero for the remaining inhabitants of Dresden.

Another claim for the reality of art is established after a complex series of negotiations with an architect, town planner, local newspaper editor, mayor, public art commissioning body, surveyor, transport consultant and local art gallery. The relationship between public and private sector reflects magnificently a reality in which the artist feels both overcompensated for and madly misunderstood.

The artist also makes work that fits between the leaves of everyday life; inside a newspaper, church, shopping mall, along a river bank, under the arches, in the factory, disused prison, prison, library, hospital, hospice, railway station, taxi, museum and historical art gallery. The placing of art 'elsewhere', outside the white box, already makes a claim for more specific function. The association with the history of a place and its current function places a different veneer upon the work. In the 1980s a great many public art projects costing a relatively grand amount of money were certainly not about establishing any sort of permanence. Only a huge loop-the-loop, a sculpture by Richard Deacon beside the railway line running from Plymouth out to the west, remains after Television South West Arts (TSWA), a huge project involving the simultaneous display of art in five British cities.

Mark Wallinger's simple, deliberately limp work with water streaming constantly from a hospipe stuck through a hole in a gallery window caused a disproportionate fuss about wasted water. Art brings anger with it and yet the level of expenditure on advertising and packaging is far greater. The combination of state funding and art causes trouble too, but it is just as annoying when curators become upset because a work is taken seriously. When a London-based Jewish organization expressed anger at the portrayal of the main character in a William Kentridge film, the sense that they were taking it too seriously, too literally, sat awkwardly with undeserved claims that this work represented, in some way, the political reality of South Africa at the time.

Back to the accepted notion of development and change and the question here is not what art says about the world but whether art should, for quasi-moral reasons, say things about the world in order to justify its existence. A tendency to interpret very quickly, instantaneously, means that the time lapse between making and effect has been shortened in a bid to find perhaps more concrete meaning. This short-circuiting of the relationship between art and the world has, at times, the effect of killing the goose before it has laid the golden egg. No sooner is something born than its meaning needs to be held down.

The extension of false ideas of education where a thing 'means' something starts with a label in the old Tate beside a Pisarro painting of an orchard. The woman hanging out the washing, it is suggested, is perhaps Pisarro's wife. This unnecessary 'explanation' narrows the gap between time, meaning, subject and non-subject. The recent exhibition at Tate Modern of Arte Povera, Italian art from the 1970s, made the same presumption of an audience expectation for total explanation. Fabro's famous sculpture with a fresh lettuce

attached by wire to a block of granite, has a sign suggesting that the lettuce, which represents freshness, has to be replaced frequently in order to remain fresh. This attention to a backstage relationship to time is wrong, the same as saying over and over that something alive needs to be fed; reducing experience and imagination to simple husbandry.

There has been a constant pull between the interpretative games of art historians and the creative language of the contemporary artist. In a frantic bid to hand a great deal of credibility to the production of art, at the point of production, a rather false oversimplification of meaning creates forced relations between account and action. So the question 'What is art for?' has to have a different answer from 'What is art?' 'What is art for?' determines a sense of purpose and purpose was always the problem.

When painting and sculpture were just about on a par with the artisanal activity of setting a fine jewel, laying mosaic or marquetry, the whole notion of function was given. Obviously, moving forward through centuries and the question of the individual and individual expression becomes key. This is relatively recent. Highly moving drawings by Charlotte Salomon of life under the Nazis play a strange relationship with us now. These pictures, which are self-expressive for Salomon, also provide accounts of a crucial historical experience, ironically bringing her role as an artist into question.

So in the shift of emphasis from the maker to the audience, the sentiment that 'I am not one of those romantic artists isolated in a garret' comes full circle. It becomes obvious that, if you are not one of those 'romantic' artists, then the illusion is that you must be doing something more real with the world. There are significant problems with this. Such good intention needs the involvement of

others nonetheless. The important shift really is from the involvement of the maker to the reception and comprehension of the viewer. Work made by the Arte Povera artists is characterized by the understanding that their highly physical, but nonetheless conceptual, work needs an audience to bring it to life, to make it exist. These artistic objects have no real autonomous and independent value apart from their possibility.

Jochen Gerz organized *Les Mots de Paris* to take place in front of Notre Dame in millennium year. Homeless people had been trained for six months to learn languages and speak to the tourists and workers to ask for money in the name of art. This caused the most enormous furore with artists saying this is not really art and journalists suggesting that these people were no longer really homeless; the public and tourists flocked to give money, anyway. An article in a newspaper can be ignored, a demonstration needs real organization, but the people involved here managed more, perhaps, than if something was done but not in the name of art. How could state money be given to this? This is going just too far.

Perhaps the greatest and most important element about any art is that its approach is three-dimensional; it is possible for anyone to approach it anywhere. Sight is democratic and so much more can be gained from the point at which something is encountered and perceived, whatever the level of knowledge, than is generally allowed or understood.

AFTERWORD
Dolan Cummings

Art: What is it good for? is a deliberately provocative title for a book. The implication is that art is not good for much. Few of us would savour the prospect of a world entirely without art though, whatever we understand it to be. The interesting question is how art justifies its claim on our time and money. Why do we bother?

There are two extreme views on this and neither is entirely satisfactory. One is represented by the slogan 'art for art's sake'. This is sometimes taken to mean that art needs no justification other than its own beauty. But surely there is more to art than just beauty. The question of what exactly 'art's sake' is, then, is never easily answered. At the other extreme is the insistence that art must serve a clear purpose. This view is rarely expressed explicitly, but tends to hover beneath the surface of any discussion about art funding. When taxpayers' money is involved, a sense prevails that degree of accountability is required. None of the essays in this collection argues for either of these extremes, but those that come closest are by David Lee, in relation to the former position, and Andrew McIlroy for the latter.

Lee began his essay by noting that he has never left the British Museum in a lower mood than when he entered. Art can make you happy. For some, that is enough. Lee makes a clear argument that initiatives to make art more useful to society only ruin the enjoyment of genuine art lovers. The problem is that different people seem to

enjoy different kinds of art. We have always struggled to come up with objective criteria for assessing the aesthetic value of art and such standards as we have are increasingly controversial. Anyone who claims that one work of art is 'better' than another lays him or herself open to charges of elitism.

Of all the essayists Andrew McIlroy has the most comprehensive idea of how and why we should value art. Art has a role to play in driving the economy, in bringing communities together and generating a sense of identity. Art can make people enjoy work and work more effectively; it can help hospital patients get better; it is good for society. To complain that all this is somehow impure is simply churlish. McIlroy's view is certainly shared by the present British Government, which sees art as a central part of its political programme, not a decorative addition to it. Nonetheless, McIlroy acknowledges that, 'Art, heritage and creativity must pass the aesthetic test or no intellectual manipulations will save them.' Whatever art is, it has to be true to itself before it can do anything else.

Ultimately, then, art is still justified on the basis of its aesthetic value or, perhaps more precisely, it is justified because of the idea of aesthetic value, which most people agree is a good thing. Intriguingly, the most coherent dissent from this consensus comes from artists themselves. As Pavel Büchler suggests, many artists want to hold onto 'artistic licence' without necessarily conforming to the standards that have traditionally sustained that concept.

Of course, if artists themselves abandon the privileged sphere of aesthetics, they expose themselves to all kinds of new demands. As Sacha Craddock observes: 'If you are not one of those "romantic" artists then the illusion is that you must be doing something more real with the world.' It may be that artists have no choice in this:

perhaps aesthetics have come to a dead end. Perhaps indeed, by transcending the prison of aesthetics, artists can find a new and exciting role for themselves.

For the most part, artists would prefer that their new role was not simply as an adjunct to government policy on urban regeneration, social inclusion or anything else for that matter. As Ricardo P. Floodsky notes, art can and does make a difference to those things in various ways. And there is nothing necessarily wrong with art that is politically engaged or even propagandisitic. To be true to themselves, however, artists must be able to connect with their public as artists, not as politicians or social workers.

It is the quality of public engagement with art that will be the measure of whatever new standards artists set. Sacha Craddock argues that art is democratic because it can be approached by anyone, anywhere. Even uneducated people can take something from art. This is obviously true if you believe that beauty is objective. We can all can look at a sculpture, a painting or even an installation, and decide whether or not we like it, and then we can argue about it. But if the focus is moving away from objective standards – indeed away from the art object itself – what is there to mediate between artist and spectator?

Inevitably the essays in this collection have raised more questions than they have answered and these are worth thinking about. We all know that books and music that seem difficult or even impenetrable on first contact often turn out to be deeply rewarding if we persevere. Is visual art fundamentally different, more immediate? If art traditionally had certain rules that could be grasped by studying art history and indeed learning the basics of drawing or painting, perhaps things have moved on. Is contemporary art so different from

ART: Afterword

what went on in the past that we cannot understand it in the same language? Is it possible to study conceptual art or is the appeal precisely that what you see is what you get? Can you be an amateur conceptual artist or is the democracy of art limited to interpretation?

While relevance may be a dubious criterion for judging art, irrelevance in itself is hardly a virtue. Or is it? For Aidan Campbell, art works best on the margins of society, unburdened by the expectation that it should be relevant. It seems that some degree of independence from the rational calculations and value judgements that dominate the rest of society is essential to art. Whether we apply an aesthetic standard instead, or whether we allow artists more leeway to invent their own rules, is more contentious. We can argue about who should fund what and how, but the ultimate judge of art is the audience.

Now go and look at some art.

DEBATING MATTERS

Institute of Ideas
Expanding the Boundaries of Public Debate

If you have found this book interesting,
and agree that 'debating matters', you can
find out more about the Institute of Ideas
and our programme of live conferences and
debates by visiting our website
www.instituteofideas.com.
Alternatively you can email
info@instituteofideas.com
or call 020 7269 9220 to receive a full
programme of events and information about
joining the Institute of Ideas.

WITHDRAWN

Other titles available in this series:

DEBATING MATTERS

Institute of Ideas
Expanding the Boundaries of Public Debate

SCIENCE:

CAN WE TRUST THE EXPERTS?

Controversies surrounding a plethora of issues, from the MMR vaccine to mobile phones, from BSE to genetically-modified foods, have led many to ask how the public's faith in government advice can be restored. At the heart of the matter is the role of the expert and the question of whose opinion to trust.

In this book, prominent participants in the debate tell us their views:

- Bill Durodié, who researches risk and precaution at New College, Oxford University
- Dr Ian Gibson MP, Chairman of the Parliamentary Office of Science and Technology
- Dr Sue Mayer, Executive Director of Genewatch UK
- Dr Doug Parr, Chief Scientist for Greenpeace UK.

ALTERNATIVE MEDICINE:

SHOULD WE SWALLOW IT?

Complementary and Alternative Medicine (CAM) is an increasingly acceptable part of the repertory of healthcare professionals and is becoming more and more popular with the public. It seems that CAM has come of age – but should we swallow it?

Contributors to this book make the case for and against CAM:

- Michael Fitzpatrick, General Practitioner and author of *The Tyranny of Health*
- Brid Hehir, nurse and regular contributor to the nursing press
- Sarah Cant, Senior Lecturer in Applied Social Sciences
- Anthony Campbell, Emeritus Consultant Physician at The Royal London Homeopathic Hospital
- Michael Fox, Chief Executive of the Foundation for Integrated Medicine.

COMPENSATION CRAZY:

DO WE BLAME AND CLAIM TOO MUCH?

Big compensation pay-outs make the headlines. New style 'claims centres' advertise for accident victims promising 'where there's blame, there's a claim'. Many commentators fear Britain is experiencing a US-style compensation craze. But what's wrong with holding employers and businesses to account? Or are we now too ready to reach for our lawyers and to find someone to blame when things go wrong?

These questions and more are discussed by:

- Ian Walker, personal injury litigator
- Tracey Brown, risk analyst
- John Peysner, Professor of civil litigation
- Daniel Lloyd, lawyer.

NATURE'S REVENGE?

Politicians and the media rarely miss the opportunity that hurricanes or extensive flooding provide to warn us of the potential dangers of global warming. This is nature's 'wake-up call' we are told and we must adjust our lifestyles.

This book brings together scientific experts and social commentators to debate whether we really are seeing 'nature's revenge':

• Dr Mike Hulme, Executive Director of the Tyndall Centre for Climate Change Research
• Julian Morris, Director of International Policy Network
• Professor Peter Sammonds, who researches natural hazards at University College London
• Charles Secrett, Executive Director of Friends of the Earth.

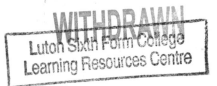

THE INTERNET:

BRAVE NEW WORLD?

Over the last decade, the internet has become part of everyday life. Along with the benefits however, come fears of unbridled hate speech and pornography. More profoundly, perhaps, there is a worry that virtual relationships will replace the real thing, creating a sterile, soulless society. How much is the internet changing the world?

Contrasting answers come from:

- Peter Watts, lecturer in Applied Social Sciences at Canterbury Christ Church University College
- Chris Evans, lecturer in Multimedia Computing and the founder of Internet Freedom
- Ruth Dixon, Deputy Chief Executive of the Internet Watch Foundation
- Helene Guldberg and Sandy Starr, Managing Editor and Press Officer respectively at the online publication *spiked*.